Location Lighting Handbook
for Portrait Photographers

Create Outstanding Images Anywhere

STEPHANIE ZETTL
PETER ZETTL

AMHERST MEDIA, INC. ■ BUFFALO, NY

Published by:
Amherst Media, Inc.
P.O. Box 586
Buffalo, N.Y. 14226
Fax: 716-874-4508
www.AmherstMedia.com

Publisher: Craig Alesse
Senior Editor/Production Manager: Michelle Perkins
Assistant Editor: Barbara A. Lynch-Johnt
Editorial assistance from: Carey A. Miller, Sally Jarzab, John S. Loder
Business Manager: Adam Richards
Marketing, Sales, and Promotion Manager: Kate Neaverth
Warehouse and Fulfillment Manager: Roger Singo

ISBN-13: 978-1-60895-594-7
Library of Congress Control Number: 2012920992
Printed in The United States of America.
10 9 8 7 6 5 4 3 2 1

Check out Amherst Media's blogs at: http://portrait-photographer.blogspot.com/
http://weddingphotographer-amherstmedia.blogspot.com/

Contents

ABOUT THE AUTHORS 6
Acknowledgments 6

FOREWORD by David A. Williams 7

INTRODUCTION 9

PART ONE:
UNDERSTANDING THE LIGHT . . . 11

1. LIGHTING 13
Quality of Light: Hard versus Soft Light . . 14
SIDEBAR: Lighting Categories 15
Contrast . 16
Direction of Light 18
 Frontal Light 19
 Backlighting 19
 Side Lighting 19

SIDEBAR: It's Natural 20
Lighting Patterns 20
 Butterfly (Paramount) Lighting 20
 Loop Lighting 21
 Rembrandt Lighting 21
 Split Lighting 23
 Ghoul/Horror Lighting 23
Lighting Positions 24
 Broad Lighting 24
 Short Lighting 24
 Front Lighting 24
Main, Fill, and Hair Lights 25
Color Temperature 26
Modifying Light 28
 Addition . 28
 Subtraction . 28
 Reflection . 28
 Transmission 28

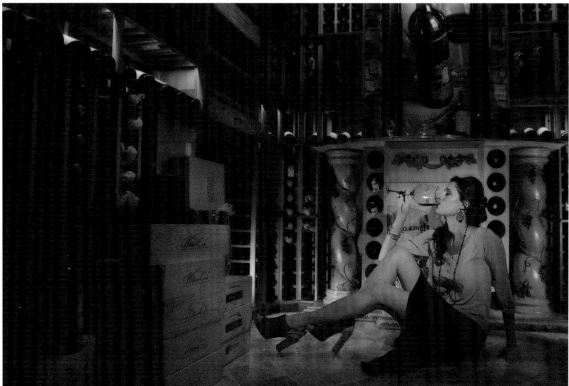

2. EXPOSURE 29
Aperture . 29
SIDEBAR: Important Facts 30
Shutter Speed 30
ISO . 32
SIDEBAR: Exposure Tips. 33
Equivalent Exposures. 33
Evaluating the Exposure 33
SIDEBAR: A Review 36
The Inverse Square Law. 36
Flash Exposure 38
Flash Sync and High-Speed Sync 42

PART TWO:
SEEING AND SHAPING
THE LIGHT 45

3. AVAILABLE LIGHT ONLY 47
SIDEBAR: Evaluating Light 47
Window Light 49
 Side Lighting. 51
 Frontal Lighting 51
SIDEBAR: Window Light Posing Tip. 52
SIDEBAR: Photographing Into the Sun 52
 Silhouettes and Backlighting 52
Bright Sunlight 52
 Metering Problems 53
 Blown-Out Highlights. 54
 Lens Flare 55
Cloudy, Overcast Skies. 56
Open Shade versus Deep Shade 57
Reflected Light 59
Lamplight . 63
Candlelight 65
Other Light Sources 65
SIDEBAR: Canned Lights: Why They
 Are Not Our Friends, Part 1 67

4. MODIFYING AVAILABLE LIGHT . . . 68
Reflectors . 68
 Why Do You Use a Reflector? 69
 How Do You Use a Reflector? 69
 Where Do You Position a Reflector?. . . . 69
 Direct Sunlight. 70
 Open Shade 71
 Window Light. 71
Scrims and Diffusers 72
 How Do You Use a Scrim?. 72
Gobos and Flags 72
 When Do You Use Gobos or Flags?. . . . 72

PART THREE:
CREATING AND
MODIFYING THE LIGHT 75

5. VIDEO LIGHTS 76

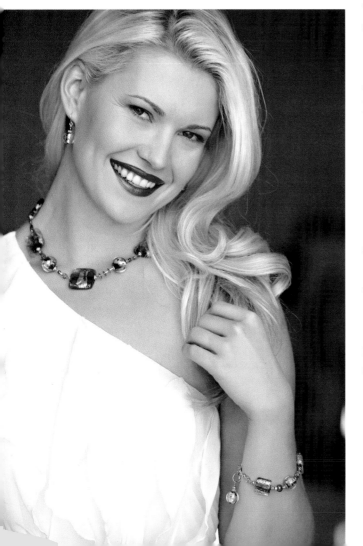

Video Lights: Halogen versus LED 76
SIDEBAR: Battery Basics 78
SIDEBAR: Single-Use Batteries 79
How Do You Use a Video Light? 81
SIDEBAR: Rechargeable Batteries 82

6. FLASH . 86
Studio Strobes versus Hot-Shoe Flashes . . . 89
Studio Strobes 90
SIDEBAR: How to Use a Light Meter 91
Hot-Shoe Flashes 94
Flash Modes . 94
Manual Mode 94
TTL Mode . 94
Flash Techniques 95
Direct On-Camera Flash 95
Fill Flash . 96
Bounced Flash 97
SIDEBAR: Canned Lights: Why They Are
Not Our Friends, Part 2 98
Off-Camera Flash 100
Sync Cords 100
Built-in Wireless Lighting 100
TTL Radio Triggers 103
Multiple Hot-Shoe Flashes 106

7. MODIFYING FLASH 108
Reasons for Modifying Flash 108
Dome Diffusers 108
SIDEBAR: An Important Note 108
Bounce Reflectors/Bounce Cards 110
SIDEBAR: Enlarging the Light Source 111
Umbrellas . 111
Softboxes . 112
Diffusion Panels/Scrims 115
Beauty Dishes 115
Ring Flashes . 116
Built-In Zoom Control 117
Snoots . 117

Grids . 117
Gobos and Flags 118
Gels . 118
Corrective Gels 118
Creative Gels 119

PART FOUR:
PROBLEM-SOLVING ON
LOCATION . 120

Harsh Noon Sun and Bright Background . . 120
Hard Sunlight, Dark Background 122
Senior Session: Available Light,
Reflectors, and Flash 124
Classic Hollywood Lighting, Part 1:
Video Lights 128
Classic Hollywood, Part 2: Video Lights &
Alternative Light Sources 130
Lady in Red: LED Light versus Flash 131
The Wine Cellar: Multiple Flashes 132
The Cyclist: Multiple Flash Units 133
Ballerina, Part 1: Multiple Flashes 134
Ballerina, Part 2: Multiple Flash Units
and Gels . 136
The Blue Room, Part 1:
Window Light versus Flash 138
The Blue Room, Part 2:
One versus Two Flashes 139
Venetian Jewelry Shoot:
Available Light, Reflectors, and Flash . . 141
The Coffee Shop: Window Light 150
Bridal Portrait in the Shade: Fill Flash . . . 152
Wedding Party Photos: Flash 153
Wedding Reception Lighting: Flash 155

CONCLUSION 157
SIDEBAR: Resources 157

INDEX . 158

About the Authors

Stephanie and Peter Zettl are photographers from St. Louis, Missouri. Stephanie got her start as a newspaper photographer and enjoyed photographing people and their relationship to the events around them. In 2003, she started her own studio specializing in documentary wedding and portrait photography. Her husband, Peter, later joined her as a photographer and business partner. Together they've developed their business into one of the top wedding studios in St. Louis, winning many local and international awards.

Stephanie is a respected lecturer and mentor who enjoys watching new photographers improve their skills. Education is important to the Zettls, and they believe that photographers should invest in studying both the technical and creative sides of photography.

More of Stephanie and Peter's work can be found on their web site at www.zettlphoto.com.

Photo by Stacey Doyle Photography.

ACKNOWLEDGMENTS

There are a lot of people we need to thank for our photography success. We would have never been able to accomplish so much without the love, support, and help of our family, friends, and mentors. Our sincere thanks for all you have done.

There are a few people who helped us with the production of this book whom we'd like to specifically thank

- To Ray Kersting and Schiller's Camera Store for always being willing to help and being so supportive of our career.
- To Ray Nason of Mac Group who was instrumental in making good things happen for this book.
- To Alecia Hoyt for helping me with models and being supportive on so many levels. I had a great time playin
- To Phil Bradon for taking the time and energy to explain fascinating technical information.
- To Dave Junion and After Dark Education for setting an example of what photo education should be like—pla hard and shine bright.
- Special thanks also to Rick Weinstein, Amber McCoy, and Lindsay Silverman.
- To those photographers that have taught and helped us see the light, shape the light, and create the light—David Williams, Chuck Arlund, Tony Corbel, Greg Gibson, Jerry Ghionis and John Michael Cooper.
- To all of our wonderful clients who invited us into their lives to document them.
- To our fabulous models who patiently sat for photos for this book.
- To Tamara Tungate, D'Shannon Llewellyn, and Ali Lee for all your help on hair and makeup for our models.

Foreword

Digital photography heralded the beginning of a new age, just as the introduction of color negative film did in 1959. Dramatic change in any industry produces benefits and problems that can be immediate but often take longer to surface.

With the advent of digital cameras, we photographers suddenly had an instant image of our subject, indicating to us the successes or failures of our exposure and lighting. Adobe Photoshop put the "darkroom" under our fingertips—without the mess, chemicals, and safe light. Epson pigment-ink printers and the makers of superb papers sealed the deal for so many of us.

And has this improved our photography? There is no doubt that the instant feedback has helped many, and in the case of experimental photography and photojournalistic-styled images, we have been set free from the manacles of film cost and processing. The myriad controls in Photoshop have made us think anything is savable, or even that anything can be made into a masterpiece of visual communication.

The profusion of visual imagery on the Internet and social media sites unfortunately tells us otherwise. So many choices in posing, composition, and particularly lighting have largely been marginalized. So many people post "Love this image" to so many poor examples.

Now, the big complaint from many is "The guests at the wedding had better cameras than I had," and many photographers are coming to believe that it actually matters. And why? Regardless of its sophistication, a camera is merely a recording device. My possession of a professional standard electric guitar does not grant me the ability to play like Eric Clapton—and no one would believe that mere possession of the instrument will do that without ability, practice, and talent.

Even when we have camera implants inside our eyeballs, our knowledge of lighting will be the thing that sets professional photographers apart from the rest. Lighting, after content, has been the single most important factor in any image that has defined the peak of photography. In so many cases, it becomes more important than the content.

Stephanie and Peter Zettl have taken the time and trouble to put tremendous research and effort into identifying the types of light, how to modify it, and its effect in a clear, concise, and well-illustrated manner that makes the learning process pleasurable. This is a book you can read once and then have on hand for a very long time—it's a constant read.

Knowledge of light, and the ability to use it and modify it, has always set photographers apart from each other. Study this book and set yourself apart—not with gimmicks, but with a quality of light.

David Anthony Williams, M.Photog. FRPS ALPE
Toronto—January 2013

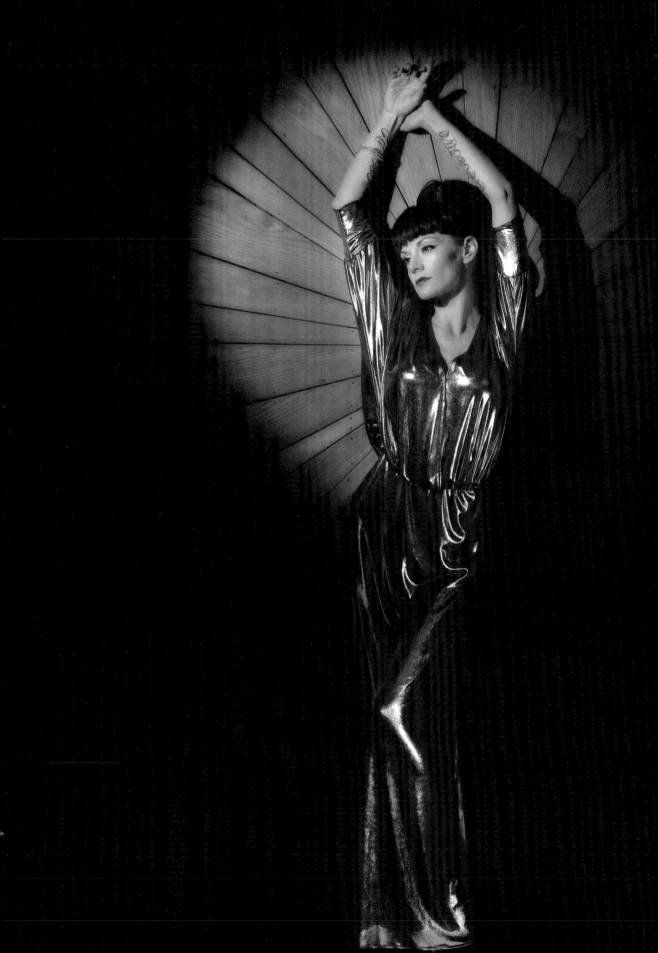

Introduction

Being able to photograph outside the studio and on location has a certain allure. It presents the photographer with an endless supply of backgrounds and settings. But unlike the repeatable conditions of the indoor studio, on-location photographers are faced with ever changing lighting conditions due to the time of day, season, and weather.

As on-location photographers, we have to be ever more aware of and have a better understanding of available lighting so that we can use it properly. Sometimes the available lighting is not the right quality or quantity. In that case, we need to add more light. Fortunately, there are many different portable options for the on-location photographer today—everything from on-camera flashes, to monolights with battery packs, to LED video lights.

This book will explore understanding, using, and shaping available light and how and why to create and shape additional artificial light when the need arises while on location.

While some on-location lighting books will show lighting situations that involve trucking in a lot of gear and hiring several assistants, this book will focus on extremely portable lighting solutions that a single photographer can handle with minimal or no assistance.

■ **THIS BOOK WILL FOCUS ON EXTREMELY PORTABLE LIGHTING SOLUTIONS.**

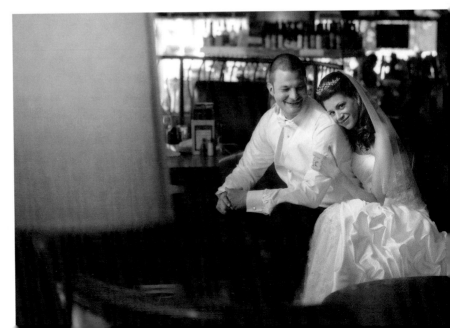

Facing page—This Old Hollywood styled fashion shoot of Jessica was lit with two LED flashlights. Nikon D3, 24–70mm lens. Exposure: f/3.5, $^1/_{160}$ second, ISO 1250. **Right**—Window light illuminate Tesha and Jerry in this casual romantic portrait. Nikon D3, 70–200mm. Exposure: f/3.5, $^1/_{250}$ second, ISO 1600.

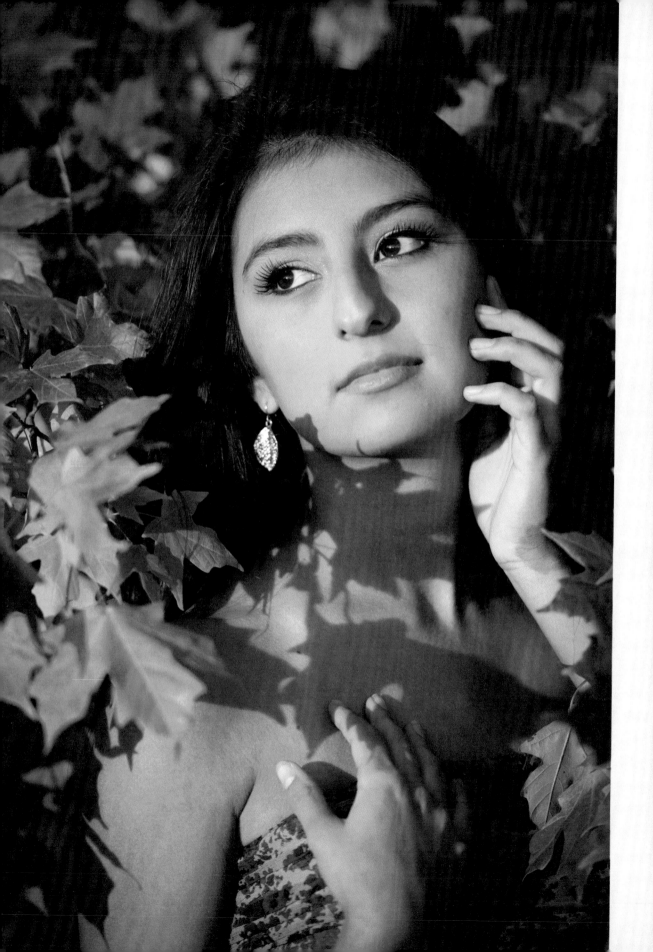

UNDERSTANDING THE LIGHT

If nothing else, being a successful on-location photographer teaches us how to be adaptable. We are often at the mercy of various and changing environmental factors. Sometimes we are fortunate enough to work in lighting situations that suit our needs, but often the circumstances are less than ideal. We might experience a situation where we have to photograph an outdoor wedding in bright noon sunlight. We might have a portrait session on a dull, cloudy day, or we might be stuck indoors in a dark, windowless room due to inclement weather. If we want to be successful photographers, we need to be able to adjust and adapt to all of these situations.

The key to success is to be able to walk into any situation and properly evaluate the existing lighting conditions. If we understand what kind of light we are working with—its quality, direction, intensity, and color—then we can properly use or modify it. In the following sections, we'll discuss the different characteristics of light so that you can better recognize, understand, and evaluate it on location.

Facing page—Hard sunlight produced the well-defined shadows in this dramatic senior portrait of Tabitha. Nikon D3, 70–200mm, f/3.2, $^1/_{1250}$ second, ISO 400.
Right—Window light illuminated a couple as they enjoyed a quiet moment together on their wedding day. While the warm glow of the overhead lamp provided a bit of fill light, it mostly added a visually interesting element to the scene. Nikon D700, 24–70mm lens, f/5.6, $^1/_{60}$ second, ISO 800. **Far right**—An overcast sky provided soft lighting for this portrait of Jennifer. Nikon D3s, 70–200mm, f/2.8, $^1/_{200}$ second, ISO 250.

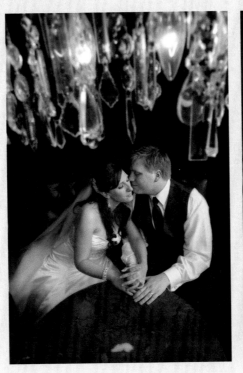

1. Lighting

The first thing you should do when setting up a photo on location is evaluate the many different light sources already available. What are their intensities? What directions are they coming from? What are their color temperatures? What effect will they have on the subject and the rest of the photograph? Once we know the answers to those questions, we gain control; we can understand how to create an effective image in that situation.

Right—Poorly used harsh light can make even the most beautiful woman seem unattractive. The harsh mid-day sun created "raccoon eyes" and other ugly shadows in this portrait. **Facing page**—By properly using the light through posing and positioning, we created a better, more attractive photo of Laura in the exact same light.

QUALITY OF LIGHT: HARD VERSUS SOFT LIGHT

Your photography will start to improve when you pay more attention to the quality of light than just the quantity of light. When you can identify its characteristics and how to use them to your advantage, you will start making photographs with greater visual impact. Quality of light is often defined as hard or soft lighting. We can recognize hard or soft light based on the type of shadows in the photo, so it's important to start by looking at the shadows in a scene you want to photograph. The shadows tell you much about the quality and direction of the light.

Hard light is the type of light found on a bright, sunny day. This quality of light comes from a single spot or point source of light (like the sun) and is very directional. It is characterized by

Left—Here we were working in a soft lighting situation—a room lit by a wall of windows. While the exposure is correct, the quality of light on Kathryn is dull and muddy. **Right**—By turning her toward the light, we were able to produce much more specularity and life in her skin and better catchlights in her eyes.

■ SOFT LIGHT IS SMOOTH, EVEN, DIFFUSED LIGHT, LIKE THE LIGHTING PRESENT ON A CLOUDY DAY.

well-defined shadows and a quick transition from light to dark. You can also create hard light with direct, undiffused flash.

Used properly, hard light can create interesting shapes and textures with the shadows. It can show detail, make colors look saturated, and establish mood—like strength and power—in an image.

Used improperly, hard light is unflattering. Hard light can be distracting when it creates ugly shadows and bad cross-lighting patterns. It can also produce too great a difference in exposure from your highlights to your shadows. This can make it difficult to properly expose for all the tones in your image and show detail in your shadows and highlights. In situations like this, use of a flash or a reflector to illuminate some of the shadowed areas will help reduce the contrast.

Soft light is smooth, even, diffused light—like the lighting present on a cloudy day. It comes from multiple directions and is characterized by undefined shadows. The softness of the light depends on the distance from the light source to the subject. The closer the light source is to the subject, the softer the light. The level of softness also depends on the size of the light source; the larger the light source, the softer the light.

To create soft light with an artificial source (the light from a flash, for example), you can place a translucent material between it and the subject, thereby increasing the size of the light source. Alternatively, you can bounce the light off of a reflective surface (e.g., a wall, reflector panel, or photographic umbrella). Light diffusion causes the light beams to scatter so that they come from many different angles.

In nature, the clouds act as a giant softbox diffuser for the sun. They increase the relative size of the light source and diffuse the light by scattering the light beams. The result is soft light with less-defined shadows.

Used properly, soft lighting can be very flattering for portraits. It minimizes the appearance of wrinkles, scars, and other skin imperfections and eliminates distracting harsh shadows in the photo. Soft lighting generally gives a very even exposure over the entire scene. It can create a calm, peaceful mood to the photograph.

Lighting that is too soft or too diffused, on the other hand, can create an image that lacks texture, color, and shape. The scene can start to look dull and dreary.

CONTRAST

Every photograph is made up of highlights, midtones, and shadows. The term *contrast* describes the transition from the brightest highlight to the deepest shadow. If you were to describe it in terms of whites, grays, and blacks, a high-contrast photo would have very bright whites, few to no gray tones, and very dark blacks. The transition from white to black would be sudden and dramatic. A low-contrast image would have a predominance of gray tones and few white or black tones. The transition from white to black would be gradual and subtle.

■ **EVERY PHOTOGRAPH IS MADE UP OF HIGHLIGHTS, MIDTONES, AND SHADOWS.**

Left—This high-contrast photo of D'Shannon has few midtones (grays) between the brightest white and the darkest black. **Facing page**—The second photo has a lot less contrast. There are more midtones in the image.

Main light at 0 degrees (on axis with camera).

Main light at 45 degrees.

Main light at 90 degrees.

DIRECTION OF LIGHT

Whether we are positioning someone in the available light or introducing additional light, we need to pay attention to the direction our light comes from. We live in a three-dimensional world, but the photographs we create are two dimensional. The only way to show dimension and depth in our photos is to take advantage of the interplay of light and dark—the shadows and highlights in our images.

Light can come from many different directions—above, below, in front, behind, and from either side. The direction of the light will determine where any shadows will fall. Shadows fall in the opposite direction of the light. They are important because they define the shape, texture, and dimensions of a subject. Shadows can flatter or detract from the subject. They make our photographs visually appealing and help set a mood.

Now let's take a moment to look at the different angles at which you can place your light and the lighting patterns that the angles create. In the many photo sessions presented in this book, we will explain why we use our lights in certain positions and combine multiple lights in different positions to create our finished photo.

■ SHADOWS FALL IN THE OPPOSITE DIRECTION OF THE LIGHT.

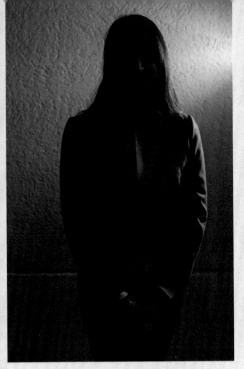

These photos show the effect of moving the light (in this case, a flash) from 0 to 180 degrees horizontally around the subject.

Main light at 135 degrees.

Main light at 180 degrees.

■ SIDE LIGHTING GIVES A LOT MORE DIMENSION AND SHAPE TO OUR SUBJECT.

Frontal Light. Frontal light (like the light that is emitted by direct on-camera flash) can produce shadows that fall behind the subject and out of view of the camera, making the image look flat and dimensionless. This type of lighting can be useful when photographing people. The lack of shadows can make the skin appear smoother and may help hide blemishes, wrinkles, and other perceived imperfections.

Backlighting. Having the light directly behind the subject, or backlighting it, doesn't reveal the depth or detail of the subject. The visible part of the subject is in shadow, and while this might be dramatic, without adding light or properly exposing for what you want visible, the subject will appear fairly dimensionless or even completely silhouetted.

Side Lighting. Side lighting gives a lot more dimension and shape to our subject. It shows detail and texture.

In addition to moving the light horizontally, we can move it vertically in relation to the subject. In the following sequence of images, notice how the light and shadow change when you move the light from 0 degrees (level with the subject) to 45 degrees above and below the subject.

IT'S NATURAL

The sun is our main light source. It comes from overhead, producing shadows that fall behind us. We are conditioned to expect light to behave this way. That's what is considered normal. Because we have one sun, we're used to seeing one set of shadows. Having two sets of shadows or shadows cast from below will normally appear unnatural in a photograph. This doesn't mean that those kinds of shadows can't work, but they will create a specific mood and should be done with a purpose.

Light from directly above rarely produces good results. When the light comes from directly above the subject, you get the dreaded "raccoon eyes"—unattractive shadows in the eye sockets. Whether we are working in direct sunlight at noon or inside a location with overhead lighting, we want to make adjustments to combat strong overhead lighting.

LIGHTING PATTERNS

Lighting patterns are based on the shadows that a light casts on a subject. Below are some of the most commonly used patterns.

Butterfly (Paramount) Lighting. This type of lighting became popular with Hollywood photographers in the 1930s. It is characterized by the butterfly-shaped shadow cast below the nose. The light is placed directly opposite the direction the face is pointing. The light is positioned fairly high (20 to 70 degrees), but it should not be so high that it causes the nose shadow to touch the lip or the eye sockets to become excessively shadowed.

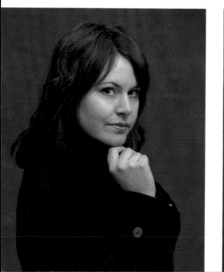

Main light 45 degrees above the subject.

Main light 0 degrees above the subject (level).

Main light 45 degrees below the subject.

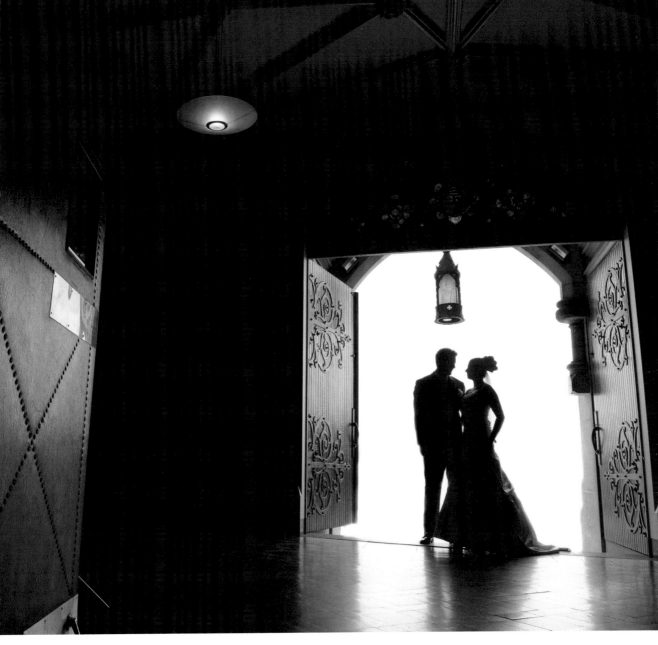

This dramatic silhouette was captured by overexposing the outside scene but underexposing the couple. Nikon D700, 24mm, f/8, $^1/_{250}$ second, ISO 400.

Loop Lighting. Loop lighting is the most often used lighting pattern. It is named after the loop-like shadow it produces under the nose. It is popular because it lights most of the face but imparts a sense of dimension. The light is placed about 30 to 50 degrees above the subject's face and 30 to 50 degrees to the right or left.

Rembrandt Lighting. Named after the famous Dutch painter, Rembrandt lighting has a very distinctive look. Rembrandt

lighting is similar to loop lighting, but the light is moved higher above (50 to 70 degrees) the subject and farther to the left or right (50 to 70 degrees). This causes the nose shadow to extend to the edge of the mouth and form a small triangle of light on the cheek just below the eye. It is a dramatic kind of light and is not necessarily an all-purpose portrait lighting pattern.

■ **REMBRANDT LIGHTING IS NOT NECESSARILY AN ALL-PURPOSE PORTRAIT LIGHTING PATTERN.**

Butterfly lighting.

Loop lighting.

Rembrandt lighting.

Split Lighting.

Horror/ghoul lighting.

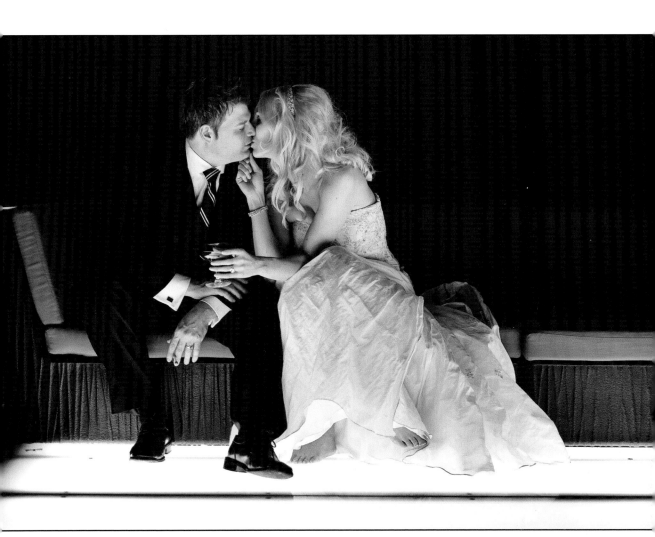

In this case, ghoul lighting made for one of our favorite images. We used the lit floor as the only light source and had our couple lean slightly toward us to better light their faces. Nikon D3, 85mm, f/2.0, $^1/_{200}$ second, ISO 800.

Split Lighting. Split lighting is achieved by putting the light source to the right or left side of the subject (90 degrees) and slightly above (20 to 30 degrees). This leaves one side of the subject's face lit and the other in shadow. Split lighting has advantages and disadvantages. It can help slim a face and hide facial imperfections in shadow. It also shows texture and imperfections in the skin. This pattern is more often used on men.

Ghoul/Horror Lighting. This type of lighting is achieved by placing the light in front of and below the subject's face. Because the light comes from below and casts shadows in a direction that we are not used to seeing, it gives a very eerie feel to the photographs. Ghoul lighting is not considered a flattering lighting pattern and should be used with caution. That's not to say that this type of lighting can't be used to make dramatic photographs. It

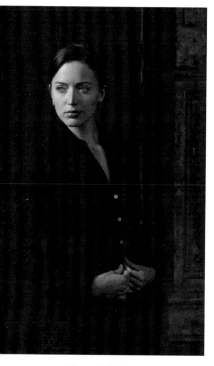
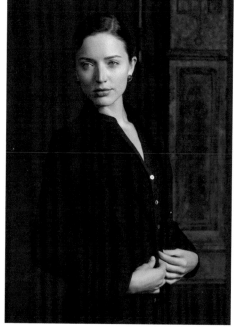
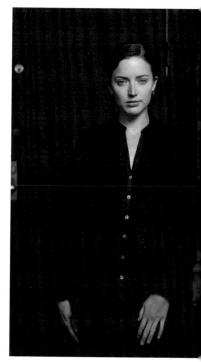

Short lighting.

Broad lighting.

Front lighting.

just needs to be done with a specific purpose—like mimicking the footlights found in stage lighting.

LIGHTING POSITIONS

Lighting positions have to do with the light's and subject's position in relationship to the camera. (For example, a loop lighting pattern can be done from a short or broad lighting position.)

Short Lighting. Short lighting places the light on the side of the face that's farthest from the camera. Short lighting works with a variety of facial shapes and can make faces appear slimmer.

Broad Lighting. Broad lighting comes from placing the light on the side of the face toward the camera. This tends to broaden the facial features, so it is good to use with narrow or angular faces. It is also useful for eliminating eyeglass glare, as reflections from the light source are directed away from the camera.

Front Lighting. Front lighting is produced when the light, camera, and subject are lined up on the same lateral axis. Because frontal light does not rake across the face the way side lighting does, it's not very good for showing depth or contouring in the face. However, it is helpful for hiding wrinkles, blemishes, and

■ **BROAD LIGHTING COMES FROM PLACING THE LIGHT ON THE SIDE OF THE FACE TOWARD THE CAMERA.**

imperfections in the skin. A lot of beauty and glamour lighting is frontal lighting.

MAIN, FILL, AND HAIR LIGHTS

The main light (also called the key light) is exactly that—the main light used to illuminate your subject. It is the light that establishes

Main light only.

Main and fill lights.

Main, fill, and hair lights.

Main light. We used a loop lighting pattern. Alecia is short lit because the source lights the side of her face that is turned away from the camera.

Fill light. The fill light is less intense than the main light and is used to lighten ("fill in") the shadows and reduce the contrast between the main light and the shadowed side of the face.

Hair light. This light is used to separate the subject from the background. Notice that it also provides some nice highlights in Alecia's hair.

Hair light alone.

Fill light alone.

your lighting pattern and direction. All other lights should be used to balance, fill, or accentuate the main light.

The fill light is positioned on the opposite side of the face from the main light and is used to manage the shadow contrast. The fill light is less intense than the main light.

The hair light is used to provide dimension and separation that prevents your subject from blending into the background. While tastes and methods vary, it is generally felt that the hair light should be less intense than the main light and should not be the first thing you see in the photo. Our eyes are drawn to the brightest point in the photo. We want the eye to be drawn to a person's face. That being said, some very dramatic portraits have been made with overexposed hair highlights.

At times when explaining about main, fill, and hair lights, some people start thinking about traditional studio lighting and strobes. Their noses scrunch up at the idea of having to deal with lighting ratios and math. The lighting setup just becomes a formula. However, to really have control over your lighting, it needs to be more than a formula. The lights you use and the way you use them should be a thought process with a photographic goal in mind. You should be thinking about who your subject is (where do I place my main light to flatter the subject?), what mood you want in your photograph (do I use a fill light to reduce contrast?), and how your subject relates to the environment (do I need to add a hair light or back light to separate my subject from the background?).

When on location, we can use available light sources to imitate what we would do in the studio. Your main, fill, and hair lights can come from many different sources. The sun can be your main light or a hair light. Reflective walls of buildings can provide some fill light. The main light can even be the light from a touchscreen of a smart phone. Light sources are very versatile; they can play each of the different roles in our photos.

In the series of images on page 25, you can see the effect of a main light, fill light, and hair light on a portrait. We used three video lights to create these examples.

COLOR TEMPERATURE

Light varies greatly in its color. It ranges from warm to cool, from orange to blue. In the morning, daylight is warm. The midday sun

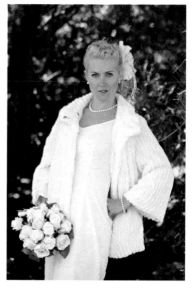

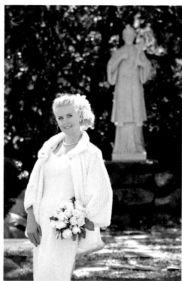

Top—To deal with the harsh midday sunlight, we put Raeme Jean in the shade to get soft, even light. **Bottom**—Here, we move Raeme Jean to the edge of the shade so that the sunlight became a hair light.

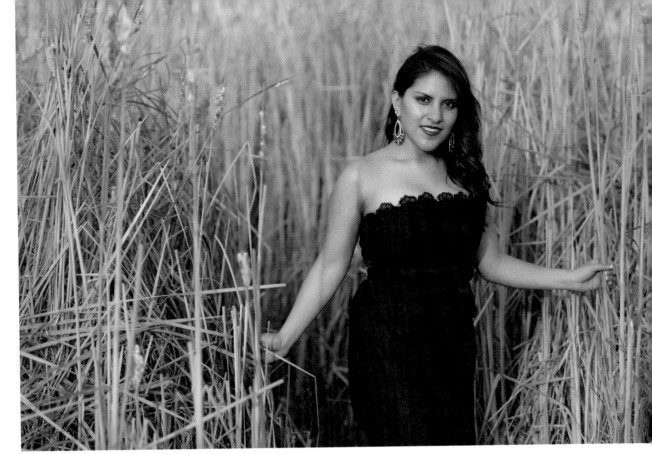

Above—In this photo, the warm afternoon sun lights Síntique. I turned her back to the sun to keep her from squinting. **Left**—Notice that this photo is much cooler and her skin tones are bluer when we photograph her from the side that is shaded from the sun. The sun still casts a warm glow to her hair.

is mostly neutral-colored. The light at twilight is cool (as is open shade). Artificial light also has different color qualities. Tungsten light is warm and often orange. Fluorescent bulbs tend to produce light with a green cast. Manufacturers of daylight-balanced bulbs produce sources with a neutral color quality.

We measure the color of light, or color temperature, in kelvins (K). The warmer or more orange the light, the lower its color temperature. Tungsten lights register close to 2800K. Blue or cool light has a higher color temperature. The color temperature of open shade is often rated at 7000K. A neutral color temperature is often referred to as daylight balanced; it is roughly 5500K.

The color of the light greatly affects the mood of the photograph. Orange, warm light will have a peaceful, soft feel. Blue light imparts a cooler, mysterious feel. The green tint of fluorescent

lights lend an industrial feel. While the neutral light of a daylight-balanced flash may be clean and "correct" light, it can lack the mood that lighting with a different color temperature will achieve.

While we should always be very aware of using the right color temperature, we also want to make sure we are not correcting our photographs to the point of making the colors sterile.

MODIFYING LIGHT

Every time you walk into a new location, it is important to evaluate the quality of the available light. Once you understand what type of light you have available, you can start to think about how you want to work with that light. There are four ways to classify how we work with the light in a photograph: addition, subtraction, reflection, and transmission.

Addition. One way to change the lighting is to add light from a photographic unit like a flash or a video light. There are many reasons for adding light. You might need to increase the quantity of light so you can take a properly exposed photograph, or you might need to add light to improve the quality of the existing light. Light can also be added to change the effect of the ambient light and make your photo much more interesting and dramatic.

Subtraction. There are times when you will want to subtract light from the scene in order to change the direction of light or improve the quality of the remaining light. For example, you might move a subject from an open field where direct sun is spilling on her from overhead, positioning her under an overhang instead. By "subtracting" the light from overhead, you have changed the direction of light, making it much more flattering on the subject.

Reflection. Reflective light is simply that—light reflected back onto the subject. Reflected light is used to control the contrast and dynamic range of a photograph by adjusting shadows. It can also serve as the main light.

Transmission. Transmissive action describes passing light through something (e.g., a diffusion panel) before it hits your subject. Transmission affects both the quantity and quality of the light illuminating your subject. Light transmitted through a material is softer and has less contrast, making for a more attractive portrait. Transmission also reduces the quantity of light hitting the subject.

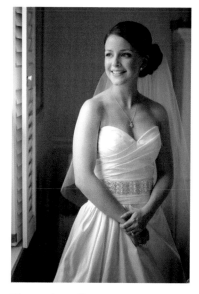

We used a reflector to camera right to control the contrast of the shadowed areas in this bridal portrait of Katherine.

■ **REFLECTED LIGHT IS USED TO CONTROL THE CONTRAST AND DYNAMIC RANGE OF A PHOTOGRAPH.**

2. Exposure

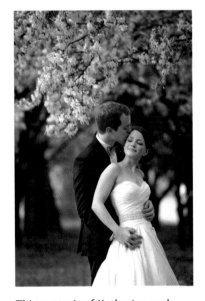

This portrait of Katherine and Andrew demonstrates proper exposure—we can see detail in the shadows and highlights. Nikon D3, 70–200mm lens. Exposure: f/4, $^1/_{250}$ second, ISO 800.

I n this book we will discuss using strobes, hot-shoe flashes, and constant light sources (like LED lights and video lights) to add light to our photographs. Before adding light to a scene, though, it's a good idea to have a solid understanding of how exposure works and how to properly set and change it. Sure, shooting in RAW and using editing software like Adobe Photoshop and Lightroom can give you a little more latitude for correcting exposure error, but it is still best to get the exposure right in the camera.

A good definition of "correct" exposure is simply the exposure needed to achieve the effect the photographer wanted. (This will be an important detail to remember later when we discuss choosing our settings when working with flash.) In more technical terms, a proper exposure is achieved when there is sufficient detail in the shadows and highlights of an image. If a photograph is overexposed, the image will be too white or bright and there will be a loss of detail in the highlights (the whites will appear washed out). If a photograph is underexposed, it will be mostly dark and black with a lack of detail in the shadows.

The three components of exposure are aperture, shutter speed, and ISO. Understanding how these components work individually and interrelate will give you the ability to make specific decisions as to the look of your photos and allow you to be more creative.

APERTURE

Aperture determines the amount of light that is allowed to enter the lens and how much will be in focus in the photo.

STANDARD PROGRESSION OF F-STOPS

f/1 f/1.4f/2 f/2.8 f/4 f/5.6f/8 f/11 f/16f/22

wider aperture *smaller aperture*

(allows in more light) *(allows in less light)*

The aperture is the opening in the lens that the light travels through. By using a diaphragm, the opening in the lens can change, allowing you to let in more or less light. Apertures are described by f-numbers, or more commonly as f-stops. The f-stop is determined by dividing the focal length of the lens by the diameter of the aperture (F-stop = focal length/aperture diameter).

F-stops follow a set sequence of numbers. By moving one step up or down the progression of f-stops, you halve or double the image brightness. The standard progression of f-stops is shown in the diagram on page 29. As you can see, f/1 has the largest opening and lets in the most light, while f/22 has the smallest opening and lets in the least light.

You will often hear photographers talk about "stopping down" or "opening up." Stopping down means you are moving from a larger aperture to a smaller one—like f/4 to f/16. If you were moving from f/22 to f/5.6, you would be "opening up" (i.e., increasing the aperture size to allow more light in).

The aperture size also controls depth of field in a photograph. Depth of field is the distance between the nearest and farthest objects in a photograph that are in focus. A photograph with a lot of depth of field will show most everything in focus, while a shallow/narrow depth of field will tend to isolate a subject by keeping it in focus and letting everything else be out of focus. Understanding this will allow you more creative control over your photographs.

It is best to choose an aperture for a specific reason such as "I want to isolate my subject from the background" or "I need to have everyone in this large group in focus." In many cases, photographers will choose their aperture based on the depth of field they want in an image and then adjust their shutter speed and ISO to create the correct exposure. However, if you are trying to capture motion in a certain way (e.g., if you want to stop motion or show motion blur), you would base your aperture and ISO selections on your desired shutter speed.

SHUTTER SPEED

Shutter speed, also called exposure time, determines how long light will come through the lens and how motion will be captured.

Shutter speeds are measured in seconds or fractions of a second. The faster the shutter speed, the less light that reaches the sensor.

IMPORTANT FACTS

A larger aperture (f/2.8, for example) will let in more light, but it will also have a shallower depth of field (there will be a narrower band of focus in the image). A smaller aperture (like f/16) will let in less light and produce an image in which there is greater depth of field (most of the image will be in focus).

Top—Image taken at f/16. **Above**—Image taken at f/2.8.

Image taken at $\frac{1}{15}$ second.

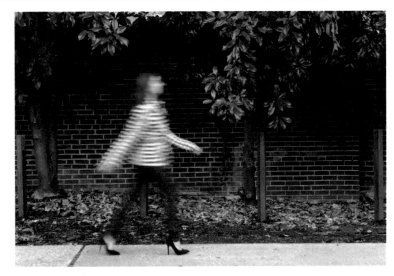

Image taken at $\frac{1}{60}$ second.

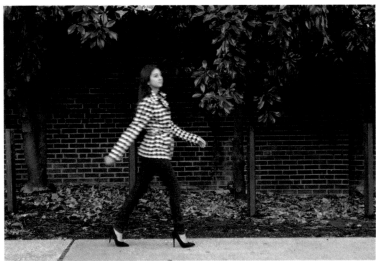

Image taken at $\frac{1}{250}$ second.

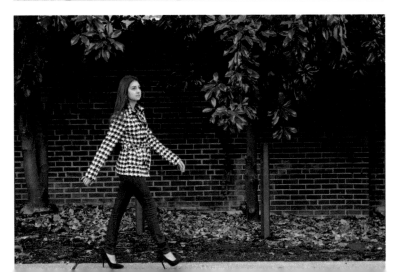

When you change your shutter speed by one step—for example, from $\frac{1}{30}$ to $\frac{1}{60}$ second, you halve the amount of light used to make the exposure. When you move from $\frac{1}{60}$ to $\frac{1}{30}$ second, you double the amount of light being used to make the exposure.

Longer exposure times (like 1 second) are referred to as "slow" shutter speeds; shorter exposures (like $\frac{1}{500}$ second) are called "fast."

The shutter speed also controls how movement is recorded in the photograph. A fast shutter speed will freeze movement. For fast-moving action photos like sports photos, most photographers will work at $\frac{1}{250}$ second or faster. Slower shutter speeds will blur all movement, including movement from the photographer who is holding the camera. When you use a slow shutter speed, the movement of your hands ("camera shake") may result in image blur, even when you are photographing still-life objects. To combat this, increase your shutter speed or put the camera on a tripod.

Maximum flash sync speed plays a role when determining your shutter speed and getting the most power from your flash. (More on this later.)

ISO

ISO is the measurement of the film or image sensor's sensitivity to light. (Technically, saying that changing a digital camera's ISO setting increases or decreases the sensitivity of the image sensor is wrong because the sensitivity of a digital sensor is fixed. However, for exposure purposes, it's the best way to think about it.) The lower the ISO, the less sensitive the film and the more light that is needed to create a proper exposure. Higher ISO numbers mean a greater sensitivity to light.

As with shutter speeds and apertures, moving along the scale of ISO speeds will halve or double your exposure with each full step.

It is important to note that as you increase your ISO you are increasing the amount of film grain or digital noise (the colored specks often seen in the shadows) in an image. Generally, you should use the lowest-possible ISO for the situation you are in to

With wedding photography, don't be afraid to change your ISO during the day. This outdoor daytime photo of Emily and Brad was taken at ISO 200.

■ A FAST SHUTTER SPEED WILL FREEZE MOVEMENT.

STANDARD PROGRESSION OF ISOs
ISO 100 ISO 200 ISO 400ISO 800 ISO 1600ISO 3200ISO 6400
less noise, more detail *more noise, less detail*

EXPOSURE TIPS

Choose a shutter speed because you want to stop motion (fast shutter speed) or blur it (slow shutter speed).

Choose an aperture that allows you to capture the desired depth of field. Larger apertures (e.g., f/1.8) produce shallow depth of field; smaller apertures (e.g., f/22) produce greater depth of field.

While you will normally not adjust your ISO too much, you can use it to maintain shutter speeds that allow you to handhold the camera in low light or to increase your depth of field without reducing your shutter speed. In certain fields of photography, such as wedding photography, you will encounter a variety of light scenarios throughout the day. Don't be afraid to use ISO 100 in the midday sun and slowly change your ISO throughout the day to end up at higher ISOs for a candlelight reception. (If you are able to get a proper exposure, most professional cameras can produce nice results even at ISO 6400.) Changing your ISO will allow you to have more control over your shutter speed and aperture.

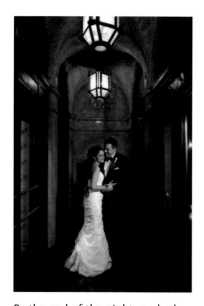

By the end of the night, we had increased our ISO to 1600 to get stready handheld shutter speeds at night.

minimize the aberrations in your images. Obtaining the correct exposure by using aperture, shutter speed, and ISO together will generally result in a lower amount of noise.

EQUIVALENT EXPOSURES

For any set amount of light, multiple combinations of aperture, shutter speed, and ISO can be used to create a correct exposure. The main thing to remember is that as you move in one direction on your aperture scale, you will need to move in the opposite direction for your shutter speed. A correct exposure at $^1/_{60}$ second at f/5.6 will also be a correct exposure at $^1/_{125}$ second (one stop faster that lets in less light) at f/4 (one stop more open that lets in more light). It's all a balancing act. Once you have that figured out, you can choose your shutter speed and aperture to suit your creative vision.

EVALUATING THE EXPOSURE

There are several different ways to evaluate your exposure:

- Use a handheld ("incident") light meter.
- Use your camera's built-in light meter.
- Review the histogram for the image on the camera's LCD screen.
- Check the camera's blinking highlights display on the LCD screen.

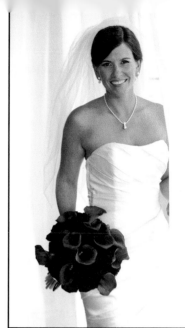

Left—Histogram of light tones on light background. Right—Bride in white on white.

Handheld light meters are held at the subject position and measure the light falling on the subject. (This reading is not influenced by the color/tone of the subject.) These meters, like all meters, are calibrated to produce an exposure with tones that average to 18 percent gray. Handheld meters are a great resource when you are working with manual flash because they give quick and accurate measurement of the output of your flash.

A camera's built-in meter measures reflected light. Like a handheld meter, a built-in meter is calibrated to give a correct exposure for a middle gray tone. This works well for the average scene, but in scenarios where the subject/scene is darker or lighter than average, a reflected meter can recommend a skewed exposure.

If we were to meter a group of groomsmen in black tuxedos, for instance, the camera would think "too dark!" and would recommend exposure settings that would render the subjects overexposed (of more "average" tones—middle gray). Likewise, if we were to meter a scene with lots of light tones, like snow or a white wedding gown, the camera meter would like to underexpose the scene as if white was middle gray.

A built-in meter can also be used in evaluative or spot metering mode. In the evaluative mode, it takes readings from several different points in the scene and combines them to recommend the best exposure. In spot metering mode, the camera meters a very small portion of the scene (1 to 5 percent). This allows you to

**■ A CAMERA'S BUILT-IN
METER MEASURES
REFLECTED LIGHT.**

get a specific reading off a certain area and not let the other tones in the scene affect the exposure reading.

The camera's histogram can be used to help you determine whether the photograph is over-, under-, or properly exposed. The histogram shows the entire range of information that your camera can capture. The highlight information is displayed on the right and shadow information on the left.

Many people will tell you that a histogram should have a certain shape for every image. However, this fails to take into consideration the dominant tones in different scenes. Even with the same light falling on them, a black cat on a black couch will have a much different histogram than a white vase against a white wall.

Truth be told, you will have mountains and valleys throughout the histogram. The things that matter most are the end points, right and left. Consider the following:

- A histogram of a good exposure is one without spikes at either end. This means that the camera was able to properly record all the tones in the scene. In general, you want the right end point to come close to the edge of the histogram without hitting it or spiking.
- A histogram with data that hits the right edge with a spike means that it is overexposed.

■ A HISTOGRAM OF A GOOD EXPOSURE IS ONE WITHOUT SPIKES AT EITHER END.

Left—Man in a dark suit in front of a dark background. **Right**— Histogram of dark tones on a dark background.

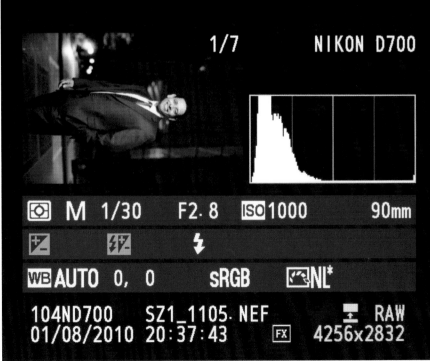

- A large gap between the end point of the histogram and the right-hand side means that the image is underexposed.

You can only use the histogram to determine proper exposure for constant light sources, such as ambient light and manual flash. It is important to note that the histogram is useful only for confirming exposure of TTL and automatic flash exposures. When the flash is in TTL mode, the light levels will change based on the camera's calculations of how much light to output. There is no guaranteed consistency of flash output from frame to frame in TTL mode like there is in manual mode.

The camera's blinking highlights display will alert you to tones that are "clipped" or overexposed. This is very helpful outdoors, as it can be hard to view the LCD screen in bright sunlight. The challenge is to know how to read the blinking highlights. We don't want large blinking highlights (meaning overexposure and lack of detail) in a white wedding gown. We'd want to bring down the exposure. However, we need not worry about specular highlights (the bright spot on a shiny object) that blinks when the rest of the scene is properly exposed.

THE INVERSE SQUARE LAW

The Inverse Square Law states that the intensity from a point light source (like a flash) is inversely proportional to the squared distance between the subject and the light source. It is expressed by the formula $I = \frac{1}{d^2}$ where **I** represents the intensity and **d** represents the distance between the subject and the light source. For example, when you double the distance between your subject and the flash, the law says that the intensity of the light will be reduced to $\frac{1}{4}$ of its original power ($\frac{1}{4} = 1/[2^2]$). This is a 2-stop difference in the exposure.

This has important implications for the look of our images. Let's take a look at a hypothetical scenario in which we are creating a one-light portrait made against a white wall. The amount of light falling on the background will depend on the distance of the light from your subject and the distance of your subject from the background. By changing the position of your light or subject—thereby changing the light-to-subject distance—your "white" background can range from white to black.

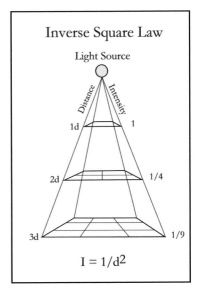

Inverse Square Law

Light Source

Distance Intensity

1d 1

2d 1/4

3d 1/9

$$I = 1/d^2$$

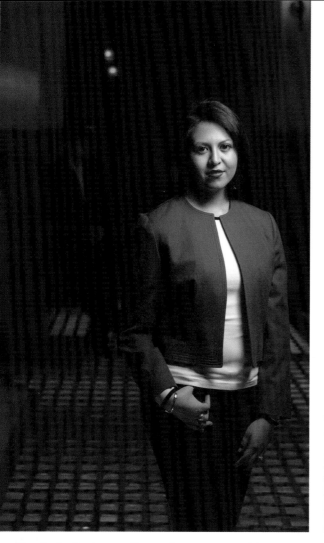 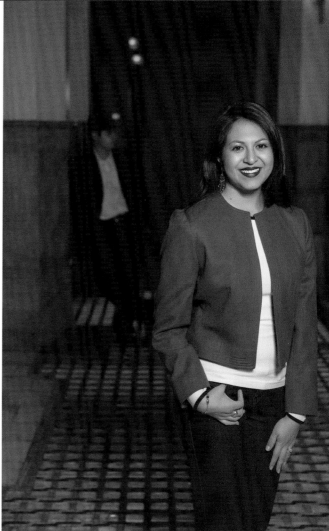

Thanks to the Inverse Square Law, we were able to create two very different images by just changing the light-to-subject distance. In both photos, Hádassa is about 10 feet in front of Baruc. In the first photo, the light is 2 feet from her. In the second photo, the light is 10 feet away from her. By increasing the distance between the flash and the subject, we reduced the overall contrast in the photo and increased the area that was relatively the same exposure.

The Inverse Square Law also shows that when it comes to large group portraits, moving your lights farther from your subjects can help ensure a more even exposure. Let's say you are working with a large group of people posed on various steps on a staircase. You will choose a greater depth of field to ensure everyone is in focus, and you will want to make sure to evenly light everyone from front to back. The farther your light source is from your subjects, the more evenly lit your scene will be. (Remember that you will need more power from your flash since it will be placed farther back.)

Conversely, for greater falloff of light intensity, move your light closer. This is a great way to isolate your subject from the background.

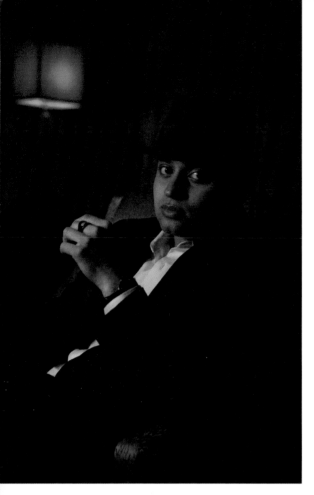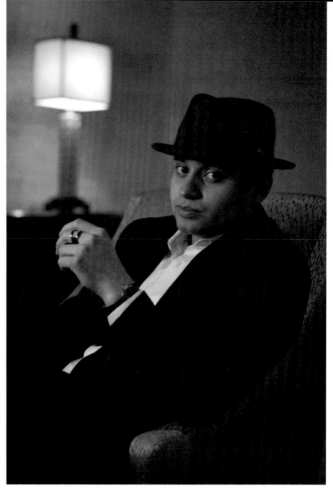

For these photos of Baruc, the speedlight output was set to $^1/_{32}$ manual flash and the aperture was set to f/4. By changing the shutter speed from $^1/_{250}$ (left image) to $^1/_{15}$ second (right image), we were able to let in more ambient light and not change the flash exposure.

FLASH EXPOSURE

For many photographers, using a flash can be intimidating at first. Before we discuss flash techniques, let's discuss how aperture, power, and ISO affect flash exposure.

Note: In this book, we will be working with two different types of flashes—small hot-shoe units and studio strobes. While the science of exposure is the same for both types of flash, modern-day hot-shoe units have advanced automatic power output modes and high-speed sync modes that allow different advantages over studio strobes.

One of the first things that photographers learn when working with manual flash is that aperture controls flash exposure and shutter speed controls ambient light. This is useful to remember when you need to make exposure adjustments quickly.

■ MODERN-DAY HOT-SHOE UNITS HAVE ADVANCED AUTOMATIC POWER OUTPUT MODES.

There will be times when you want your ambient light to be more prominent in the photos and other times when not. You can adjust your shutter speed to achieve this. Simply slowing down or speeding up your shutter speed will allow more ambient light to register. You may want to use a slower shutter speed in a low-light situation to collect more light to show a sense of location or mood in a photograph. You can use higher shutter speeds in brightly lit scenes to create more dramatic photographs where your subject stands out. As long as you're shooting at maximum sync speed or

You shouldn't think about changing your shutter speed just to let in more light. It can also be used to reduce the amount of ambient light in the image. In these images of Georgia, we were able to make the background darker by simply changing our shutter speed from $1/60$ (left image) to $1/250$ second (right image). The flash exposure on her stayed the same because the aperture of f/5.6 and the manual flash power output of $1/4$ power did not change.

For these photos of Tabitha, we set up a flash in a softbox. It was set to manual $1/32$ power and the shutter speed was $1/160$. The shutter speed and the power output remained constant. Notice how moving from f/2.8 to f/22 made the photo go from over- to under-exposed, proving that aperture controls manual flash exposure.

Image shot at f/2.8.

Image shot at f/5.6.

Image shot at f/11.

Image shot at f/22.

slower, your shutter speed will have no control over the amount of flash hitting your sensor.

So why doesn't shutter speed control manual flash exposure? The flash sync speed of most cameras is $1/250$ second or less. The slowest speed of the flash burst on the average hot-shoe flash is

$^1/_{880}$ second at full power. (The flash burst speeds are even faster at reduced flash output—$^1/_{38,500}$ second at manual $^1/_{128}$ output.) No matter what your shutter speed is (at maximum sync speed or less), the camera's shutter speed will always be slower than the burst of flash. The full amount of the flash output will always fully register on the image sensor.

Aperture, on the other hand, limits the amount of light coming through the lens. The larger the aperture, the more light the lens will

Image shot at f/4.

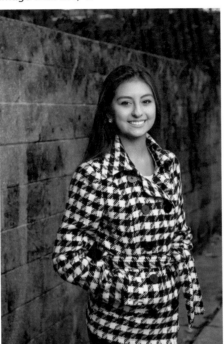

Image shot at f/5.6.

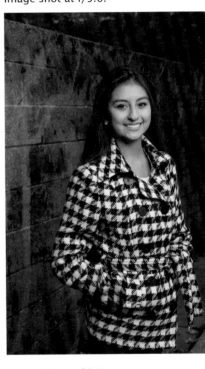

Image shot at f/8.

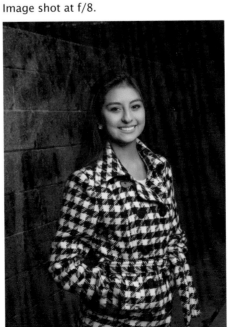

Image shot at f/11.

With TTL flash, the flash considers the change in aperture and ISO and adjusts the flash output. As long as you stay within the power range of your flash, you can change the aperture and the flash will automatically adjust to provide a correct exposure. Here, the camera was set to ISO 400 and $^1/_{160}$ second.

allow in. The smaller the aperture, the less light the lens will allow in. There will be situations when you will need to adjust your flash exposure via the aperture and not the flash output. If you have your manual flash set to full power and your image is underexposed (or if you are at minimum manual flash output and your image is still overexposed) and you cannot change your flash's distance to the subject, you can adjust your aperture to achieve a proper exposure.

We talked earlier about how proper exposure is determined by aperture, shutter speed, and ISO. So how does ISO relate to flash exposure? ISO affects both ambient light and flash equally. Increasing your ISO increases the amount of light collected by the sensor, whether it's ambient or flash.

Here are some reasons why you might change your ISO:

- If you are at full flash power but underexposed and cannot open up your aperture any wider, increase your ISO.
- If you need more ambient light but cannot reduce your shutter speed without risking camera shake, increase your ISO.
- If you want a shallow depth of field but your shutter speed is faster than maximum sync speed, decrease your ISO.
- If you want to remove all ambient light from the scene and you are at maximum sync speed, decrease your ISO.

The above information holds true when working with manual flash. It changes a bit when you are using TTL flash. In i-TTL mode, the flash takes into consideration any changes to your ISO and aperture and adjusts the flash output accordingly. This means that in TTL mode, you can use your aperture, ISO, and shutter speed to control the ambient light.

In the example on page 40, you saw that adjusting the aperture in manual flash mode led to overexposing the subject. In the second example of i-TTL, I was able to adjust my aperture, and the flash output was adjusted automatically.

FLASH SYNC AND HIGH-SPEED SYNC

Flash-sync speed is the maximum shutter speed you can use when the camera's shutter is completely open and the flash can fully expose the sensor. Most cameras' flash sync speeds are $\frac{1}{250}$ second

Because I was working with manual flash and could not go above $\frac{1}{250}$ second sync speed and because I could not reduce my ISO below 100, the only way to reduce the ambient light in this photo was to choose a smaller aperture. I went from f/8 (top photo) to f/16 (bottom photo). I had to increase my flash power to compensate for the change in f/stop. Remember that the f/stop controls manual flash power.

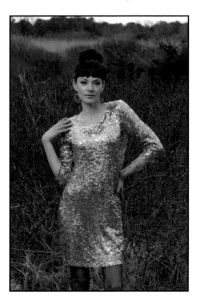

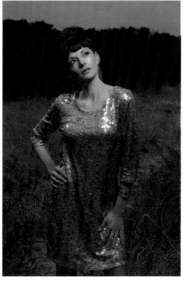

The flash was set to $^1/_4$ manual power. You can see the power loss of almost 2 f-stops as we switched from the maximum sync speed of $^1/_{250}$ (left image) second to high-speed sync mode at $^1/_{320}$ second (right image).

or less. It is impossible to get a completely exposed frame when you use a standard flash mode over the maximum sync speed. At shutter speeds higher than the maximum sync speed, one of the shutter curtains will be covering part of the frame when the flash fires. At very high shutter speeds, the space between the first and second curtain is just a small slit that travels across the sensor. This

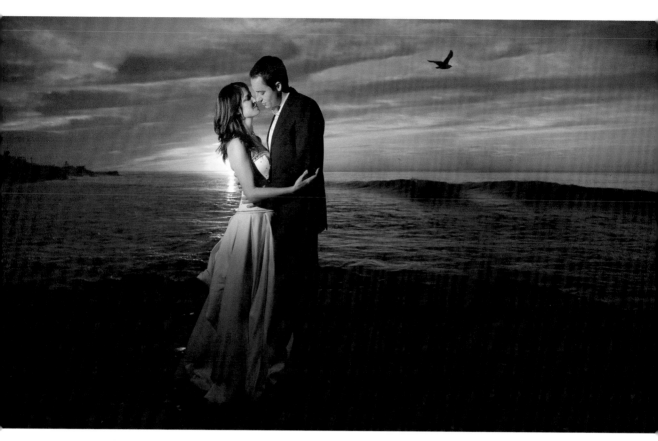

means that you will get a black bar (or bars) obscuring your photo when you fire a single pop of flash at any time during the exposure.

High-speed sync is a helpful mode found on modern hot-shoe flashes. It allows you to use your flash at shutter speeds above the maximum sync speed. Instead of sending out one single burst of light, in this mode, the flash sends out multiple bursts to follow the shutter as it moves across the image plane. This ensures that the frame is completely illuminated by flash.

It is important to note that when using high-speed sync, you greatly reduce the power output of your flash. It takes a lot of energy to produce the continuous light that you need for high-speed sync. Switching from maximum sync speed to high-speed sync in manual mode will cause a reduction in power of 2 to 3 stops. In real terms, this means that your flash is reduced to, at maximum, $^1/_4$ to $^1/_8$ its normal full power.

High-speed sync is useful when you want to work at wider apertures in daylight, without overexposing your background.

High speed sync let us use a smaller f-stop to get a shallower depth of field and a faster shutter speed to expose the sunset the way we wanted. Nikon D700, 24–70mm lens. Exposure: f/4, $^1/_{1600}$ second, ISO 200.

SEEING AND SHAPING THE LIGHT

"You have to learn to see the light!" Veteran photographers torment newbies with this age-old quip that is as inscrutable as it is profound. And yet seeing the light, far from being mysterious, is a learnable skill. In this part of the book, we're going to discuss exactly how to do just that—see the light. We'll be able to know what to look for as we enter a given lighting situation.

We will consider various kinds of light sources, the qualities each has, and how those qualities show up in our photographs. We will be able to evaluate the available light and see, for example, where to put our subject in the frame for best effect. If there is more than one available light source, we will be able to decide which should be the main and whether or not other sources in the frame can play a supporting role or must be completely eliminated.

After that we'll talk about what we can do to shape the light to make it better. Changing basic aspects like direction, intensity, and color seem out of our hands sometimes, but are they really? Light shapers and modifiers—like reflectors, diffusion panels, and scrims—can help us add to, subtract from, soften, and alter direction—we'll talk about when and how they work best.

The sheer curtains served two purposes in this image; they created a soft, romantic feel and blocked out some of the warm tungsten light from the cafe that competed with the cool-colored window light. By blocking out some of the light, I was able to avoid some difficult mixed lighting and create more directional light coming from the fading window light. Nikon D3s, 24–70mm lens. Exposure: f/2.8, $^1/_{125}$ second, ISO 1600.

3. Available Light Only

As we mentioned earlier, it's important that every time we walk into a new location, we take a moment to evaluate the quality and quantity of the available light. Remember that available light refers to any light that exists when you encounter the scene—it can be natural light from the sun, artificial light (like from a lamp), or a combination of both.

In this section, we'll discuss how to work with various available light sources (both natural and artificial) without having to modify them or add more light.

Facing page—Bright sunlight poured through the window, creating hard shadows in this photo of Briley. **Right**—Soft, diffused window light illuminated Ali for this relaxed portrait.

EVALUATING LIGHT

Remember, when you evaluate the light in your scene, you're trying to determine the following characteristics:

- **Quality:** Is the light hard or soft?
- **Direction:** Where is the light coming from?
- **Color:** Is the light warm or cool?
- **Intensity:** What will my exposure be? Will I choose to adjust my aperture, shutter speed, or ISO to get a correct exposure?

Elizabeth and Brad enjoyed an "almost" alone moment in the window light of a local restaurant on their wedding day. Nikon D700, 24–70mm, f/2.8, $^1/_{60}$ second, ISO 800.

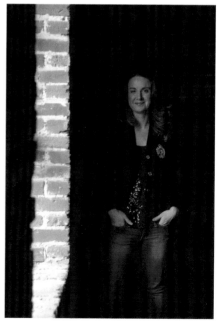

Note how the quality and direction of light changed on Shannon's face as we moved her around the window. In the first image, she stood directly in front of the window and was side lit. The shadows on her face are not very attractive. The second photo shows her at the edge of the window's cone of light. Her face appears better lit. The last photo shows her just outside the window's cone of light. While the light effect is better than it is in the first photo, it's not as nice as the light created by the edge of the window's cone of light.

WINDOW LIGHT

Many people like to work with window light because it can provide beautiful, soft, diffused light; it is generally easy to work with; and it doesn't require bringing a lot of equipment on location. However, not all windows are created equal. Just because a room has windows doesn't mean you'll have great lighting conditions. If you want to photograph people using window light, there are some things to watch out for and some techniques that will help ensure your success.

Window light can be harsh or soft. Its quality depends a lot on the direction the window faces. Constant, diffused, soft lighting generally comes from a north-facing window (in the northern hemisphere). Windows facing east or west will obviously have sunlight streaming directly through them at some point during the day. This kind of light will usually be hard and can be difficult to use for portraiture. To correct this, you can use some sort of diffusion (like sheer curtains) to modify the light. (More on this in the next chapter.)

As sunlight comes through a window, it forms a cone of light. The sweet spot—the area where the light has good specularity (i.e., shine or reflectivity) for portraits—is on the edge of the cone of light. As you examine the light, you'll notice that this specularity creates an attractive glow on the skin. *(Note:* Specularity is not to be confused with shiny or oily skin.)

■ **CONSTANT, DIFFUSED, SOFT LIGHTING GENERALLY COMES FROM A NORTH-FACING WINDOW.**

Left—The window light was more intense on Heather's bodice than her face. **Right**—By sitting her down, we were able to put better-quality light on her face. Notice how her blue eyes "pop" in the second photo as the light hits them.

The higher the sun is in the sky (midday), the more acute the angle of light. This means that even if the subject is standing close to the window, the good-quality lighting may be hitting well below the face. To get the good-quality lighting on the face, you

■ THE HIGHER THE SUN IS IN THE SKY, THE MORE ACUTE THE ANGLE OF LIGHT.

Top left—Stephanie and her bridesmaids got ready in a church meeting room that featured overhead fluorescent lights and one small window. During the key getting-ready moments, I turned off the overhead lights and positioned the subjects in front of the window. The quality and direction of light was much better. **Bottom left**—Never be afraid to move furniture. For this portrait of Storey, we moved her couch away from the wall to improve the quality of light that would fall on her face.

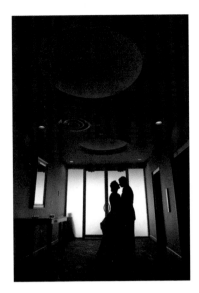

Left—Side lighting. **Center**—Frontal lighting. **Right**—Silhouette.

can move the subject closer to the window or have them sit in a chair.

It is a good idea to turn off any overhead lights, as they can compete with the window light and cause color contamination. Artificial light and window light generally have two different color temperatures. (Window light is blue and tungsten light is orange.) When they combine, the result can be unattractive "dirty" light. Turning a table lamp on in the background can add warmth, depth, and dimension to a window-light photograph.

Let's discuss a few ways to position your subject in window light and things to look out for.

Side Lighting. Side lighting is very directional light; it causes shadows and reveals texture in the subject. Whenever we photograph a bride in window light, we have her angle her body away from the light and turn her face toward it. We want more frontal "beauty" light on her face, and we want the light on her dress to come from the side to show more detail and texture. If we have her body turned into the light, we not only risk overexposing the bodice of her dress, but the detail in her dress disappears.

Frontal Lighting. Frontal window light is very popular for portrait lighting because it generally produces soft, diffused light with few shadows. Lack of shadows (and thus less texture) is great for making the skin look flawless. It also creates catchlights in the eyes. The key to effectively using frontal light is to make sure that the subject is actually in the window light and not being lit by light

■ SIDE LIGHTING IS DIRECTIONAL; IT CAUSES SHADOWS AND REVEALS TEXTURE IN THE SUBJECT.

WINDOW LIGHT POSING TIP

When photographing a bride, turn her face toward the light and her bodice away from the light. This will create flattering light on her face and show the texture of her dress, without overexposing the highlights.

Left—Dress bodice turned toward light. **Right**— Dress bodice turned away from the light.

reflecting off the floor. Light bouncing off the floor causes ghoulish shadows on the face.

Silhouettes and Backlighting. You can create compelling images by placing your subject in front of the window and photographing toward it. If you expose for the window light, your subject will be silhouetted in front of the window. If you expose for your subject, the window will become overexposed and "blown out." Note that when using this technique, your photo can have a low-contrast, washed-out look; while this isn't necessarily bad, you need to know why you're doing it.

BRIGHT SUNLIGHT

Direct sunlight is usually not desirable for portraits. It's a hard light characterized by well-defined shadows. When people face the sun, the lighting can be too bright and harsh, causing them to squint or completely close their eyes. If you are photographing in midday sun, with the sun directly above you, your subject's eye sockets will generally be shadowed, resulting in "raccoon eyes."

That said, sooner or later you'll be forced to work on location in bright sunlight. Here are some ways to deal with bright sun without using modifiers or adding light to balance or overpower it.

PHOTOGRAPHING INTO THE SUN

• Meter for your subject's face.

• Make sure that you photograph against a darker background so that your subject is well defined.

Left—Katy and Brent wanted engagement photos made from their apartment's rooftop, with the arch in the background. There was little I could do to quickly and easily deal with the bright sun. Instead of having them look into the lens (and risk squinting), I had them look at each other, and I asked Brent to say something to make her smile. I think this image has a lot of personality. Of course, we took photos in other locations with them looking directly into the camera. Nikon D3, 70–200mm, f/2.8, $^1/_{1600}$ second, ISO 200. **Right**—By positioning Nicole and Brady with their backs to the sun, we prevented any squinting and used the sun as a hair light. Nikon D3, 70–200mm, f/4, $^1/_{500}$ second, ISO 400.

- Don't make your subject look into the sun. This might seem like an obvious way to avoid squinting, but sometimes we're so concerned about running to open shade that we forget that this technique will work.

- Photograph into the sun. Another quick and effective way to deal with photographing in bright sunlight is to simply turn your subjects so that the sun is behind them. This solves the problem of squinting and prevents harsh shadowing on the face. The sun serves as a natural hair light, and you can create some really great images.

Shooting in bright sun poses some challenges. Some of the difficulties you will face include metering problems, blown-out highlights, and lens flare.

Metering Problems. If you are working in matrix (Nikon) or evaluative (Canon) metering mode and you let your camera do the exposure metering for you while shooting into the sun, your subject will generally be underexposed and possibly completely

silhouetted. You need to meter specifically for your subject's face. You can do this by changing your metering mode to spot metering or increasing your exposure compensation. Exposure compensation will take the metered exposure and automatically increase (or decrease) the exposure in your image by the number of stops you set. With backlighting, you will always increase the exposure to properly expose for faces. The number of stops you will need to overexpose by will depend on the intensity of the backlighting.

Blown-Out Highlights. To get a proper exposure of your subject's face, you'll generally need to increase the exposure. This will cause you to overexpose the background and highlights in the photograph. If you're not careful, people's hair (especially light-colored hair) or a bride's veil can be completely blown out and unrecognizable. To combat this problem, place your subject against a darker background. While there might still be some blown-out highlights, the shape of the hair, veil, and head of your subject will be well defined.

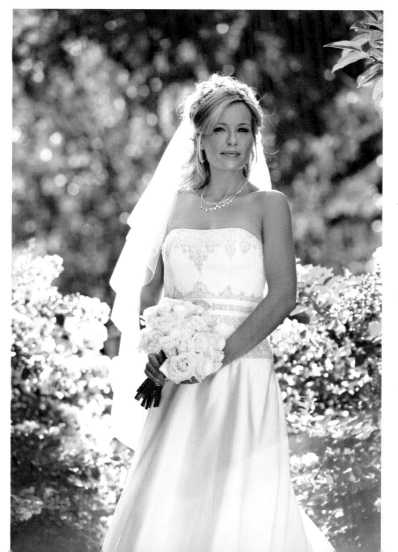

Above—Matrix metering. No adjustment. Nikon D3, 70–200mm, f/4, $^1/_{1000}$ second, ISO 400. **Top**—Matrix metering with +2 f-stop exposure compensation. Nikon D3, 70–200mm, f/4, $^1/_{250}$ second, ISO 400. **Left**—April's white veil is completely blown out due to the bright afternoon sun, but since she is framed against a darker background, the veil's shape is still apparent. Nikon D700, 70–200mm, f/4, $^1/_{640}$ second, ISO 400.

Top left—This photo of Sutton looks hazy due to lens flare.
Bottom left and right—To correct for this, I had an assistant block the sun from directly hitting the front element of my lens. Nikon D3, 70–200mm, f/4.5, $^1/_{250}$ second, ISO 200.

Lens Flare. Lens flare occurs when sunlight directly hits the front element of the camera's lens. In some cases, a little lens flare can be interesting and add a nice artistic touch to a photograph. Other times, lens flare can be distracting and ruin a photograph. Some of the problems with lens flare are that it reduces contrast in a photograph (making it look hazy) and can make it difficult to focus and get an accurate exposure. To reduce lens flare, you can

use a lens hood, remove UV filters (these can increase lens flare), change your composition so that no light directly hits the front of the lens, or place something (like a tree, lamp pole, building, or even another person) between you and the sun to block the light from directly hitting your lens.

Even with overcast skies, there is direction to the light. Notice how changing Analisa's position changes the quality of light in the photographs. In the left image, she is facing away from the light. In the right image, she is facing the light. Canon 7D, 24–70mm, f/4, $^1/_{250}$ second, ISO 250.

CLOUDY, OVERCAST SKIES

Many people enjoy working in cloudy, overcast lighting conditions because the clouds act as a giant softbox. The light is soft and diffuse. You don't have to worry about harsh shadows or squinty eyes. However, there are a few thing to watch out for to ensure that you are making the most of this light.

The sun may be hidden behind clouds, but that doesn't mean the light lacks direction. Note the sun's position and compose your image accordingly. You will see a difference in the quality of the light on your subject, especially in the catchlights in their eyes.

Not all clouds are created equal. The thickness of the clouds will make a huge difference in the quality and intensity of the light. Thin cloud formations will cause a moderate level of diffusion where you can see a contrast between the highlights and the shadows. If the day is very overcast, you may find your photos appear flat, with little detail or contrast. In that case, it would be wise to add some additional light with a reflector or flash (see chapter 4).

OPEN SHADE VERSUS DEEP SHADE

When the bright sun is too harsh and causes unattractive shadows on your subject's face, an easy solution is to move to a shady spot. But remember, not all shade is created equal.

You'll sometimes hear photographers talk about open shade and deep shade. There is a difference between the two. Open shade, like you might find on the shady side of a building, protects the subject from harsh sunlight but still allows light to come from

Overcast skies meant the natural lighting in this photo was flat and without a lot of direction.

Due to a scheduling conflict, we had to shoot this kids' session at 11:00AM, when the sun was at its brightest. To deal with the harsh overhead light, I moved the kids under the shade of the trees. I set the white balance to cloudy to warm up the scene. What really makes the lighting nice in this image is the hair light that comes from sunlight bouncing off the concrete behind them. Nikon D3, 70–200mm, f/4, $^1/_{640}$ second, ISO 400.

Left—Open shade has light coming from above that is fully illuminating the scene. **Right**—Deep (or covered) shade has much more direction to the light. In these photos of Meredith, you can see the difference between open shade and deep shade created by stepping under the pavilion.

Left—Notice that Meredith's eyes are dark and there are some unattractive shadows on her face. **Right**—By shooting above her and having her look upward, we created much better light on her face.

above. Because your subject is still exposed to the light coming from the open sky, you'll sometimes also hear this referred to as skylight. It is very soft light, and most of the time it is easy to work with. However, it can lack direction and appear quite flat. As the light comes from above, your subject's eyes may appear dark and dull. A remedy is to shoot slightly above your client so they are looking up toward the light and it is fully illuminating their eyes.

In deep shade, like you might find under a tree or on a covered porch, the subject is shielded from the harsh sunlight. One of the benefits of deep shade is that, because light is blocked from above, it has more direction. If the shade is too deep, though, the light may be flat and your images may have a low-contrast, dull quality.

It is also worthwhile to note that the color of light in shady areas is cool or bluish in color. Deep shade tends to be a little cooler

■ IN DEEP SHADE, THE SUBJECT IS SHIELDED FROM THE HARSH SUNLIGHT.

than open shade. You can correct for the blue tone by changing your white balance or color correcting in postproduction. If I am shooting extensively in the shade, I set my white balance to the cloudy or shady setting (sometimes the shady setting can be a bit warm for my tastes) or do a custom white balance setting. This will warm up the photos and save me a step in processing my images.

■ IF I AM SHOOTING EXTENSIVELY IN THE SHADE, I SET MY WHITE BALANCE TO CLOUDY OR SHADY.

REFLECTED LIGHT

Just because you don't have a reflector with you doesn't mean you can't find a natural one to use. Natural reflectors are everywhere. The next time you're out walking around, look for all the surfaces

Right—For this photo of Chad, the intense setting sun shining through the abandoned ware-house reflected off one of the pillars and provided nice directional fill light. Nikon D3, 24–70mm, f/3.2, $^1/_{160}$ second, ISO 400.
Below—Pull-back shot to show pillar.

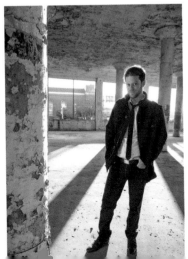

Left—City streets are often filled with bits of light reflecting off windows. **Top right**—This overall scene shows the effect of the sunlight hitting a building. **Bottom right**—We used one of those spots of reflected sunlight to selectively light the bride and groom's faces. Nikon D3, 70–200mm, f/3.2, $^1/_{1250}$ second, ISO 400.

■ WE LOOK FOR BUILD-INGS, WINDOWS, OR WALLS THAT REFLECT SUNLIGHT BACK INTO OPEN-SHADE AREAS.

you see reflecting the sun. Walls, windows, cars, signs, metal doors, and buildings are reflective surfaces that can provide you with additional light.

The nice thing about reflected sunlight from a building or wall is that it is less intense than direct sunlight and is more diffused. However, it still retains the beautiful specularity of sunlight and can still create dramatic shadows and direction of light.

We often look for buildings, windows, or walls that reflect sunlight back into open-shade areas. When you find the right area, it can create a spotlight effect on your subject. Your subject is well

lit, but the surrounding area is noticeably darker. This can make for a very dramatic photo. *(Note:* Light reflected from a reflective surface will pick up the color of that surface.)

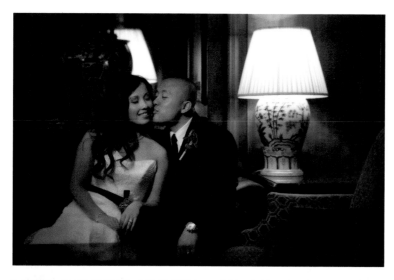

■ LIGHT REFLECTED FROM A REFLECTIVE SURFACE WILL PICK UP THE COLOR OF THAT SURFACE.

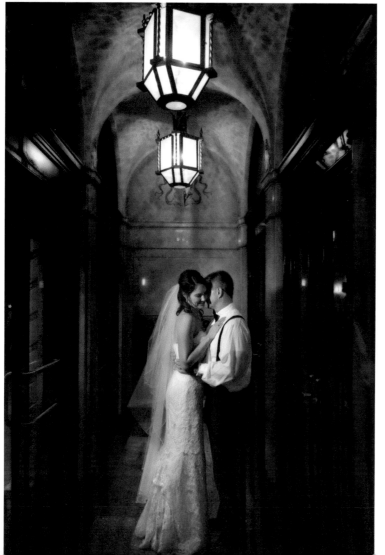

In both of these photos, the lamplight did not properly light the bride and groom's faces. We supplemented the light with a touch of video light but did it in such a way that it gave the impression that the light was coming from the lamp. The top photo was made with table lamps and video light. Nikon D3, 70–200mm, f/2.8, $^{1}/_{125}$ second, ISO 3200. The bottom photo was made with overhead accent lamps and video light. Nikon D3, 24–70mm, f/2.8, $^{1}/_{60}$ second, ISO 1600.

LAMPLIGHT

Like all available light, lamplight is great to work with because it's there, at the ready, and it's free. Lamplight often has a warm glow, and it can create an intimate mood in the image. There is a downside, though: the intensity of lamplight tends to be fairly low, so you'll need to work with higher ISOs, slower shutter speeds,

■ LAMPLIGHT OFTEN HAS A WARM GLOW, AND IT CAN CREATE AN INTIMATE MOOD IN THE IMAGE.

Right—This photo of Vanessa was taken in a hotel room and lit with a floor lamp. Because the lamp shade was fairly translucent, it created beautiful, soft light for the portrait. Nikon D3, 85mm, f/1.8, $^1/_{80}$ second, ISO 1000. **Below**—Pull-back photo of Vanessa with the lamp.

and wider apertures. You might even consider working with a tripod.

Lamplight varies in color. The illumination from traditional incandescent bulbs has a warm orange cast. Compact fluorescent bulbs have a green cast. Other fluorescent bulbs are daylight balanced and have a neutral color balance. Also, the color and type of the lamp shade can also affect the color of the light.

Lamps can be difficult to work with because it might not be possible to get the lamp or your subject in the right position for ideal lighting. Overhead lamps can be like midday sun and cause unwanted shadows in the eye sockets and under the nose. For table lamps, you might find yourself moving lamps or furniture to get the subject in just the right light. We have sometimes been known to remove the lamp shade to give better direction and intensity of light if the lamp itself will not appear in the photograph.

We often use table lamps as accent lights in our photos, but we rarely use them as the main light. Table lamps can add beautiful

■ WE OFTEN USE TABLE LAMPS AS ACCENT LIGHTS IN OUR PHOTOS.

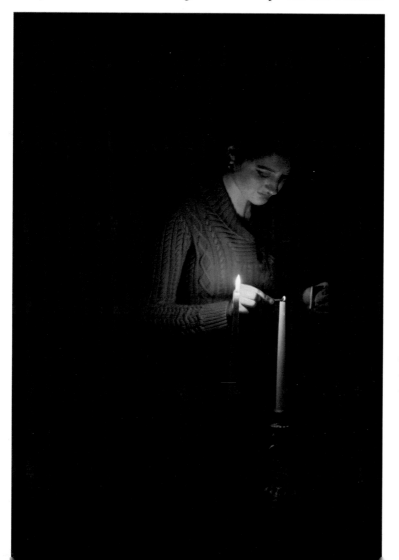

Notice the warm glow and the limited light that the candle produced (candle light has a very warm color temperature!). I had to shoot this image at ISO 6400 to have shutter speeds that let me handhold the camera. Nikon D3, 85mm, f/1.4, $^1/_{100}$ second, ISO 6400.

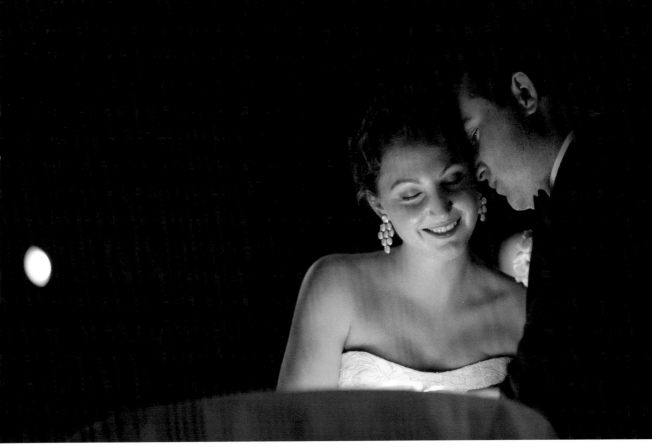

We used votive candles on a cocktail table to create a romantic ending photo of this bride and groom. By having Aggie look down and shooting from below, we were able to create flattering light on her face from the underlight. Nikon D700, 85mm, f/1.4, $^1/_{80}$ second, ISO 3200.

warmth to the background of a photograph. For instance, when working with a bride, I often turn off the overhead lights and turn on all of the table lamps when I enter the room in which she is getting ready for the ceremony.

CANDLELIGHT

Photographing by candlelight can be difficult. The intensity of the light is so low that even at high ISOs and wide-open apertures, you can be working at very slow shutter speeds, which makes it difficult to handhold the camera.

Because single candles are a small light source and light only a limited area, it is important to carefully position your subject in the light, as there is generally a quick falloff from light to shadow. Of course, this can produce beautiful and atmospheric portraits.

OTHER LIGHT SOURCES

While we've considered several common sources of available light, there are many available light sources that we haven't specifically

This engagement photo of Meghan and Mike was lit by street lights and car headlights. Anything that gives off light can be a light source for portraits—you just need to learn how to evaluate it so you can properly use it.

■ IT IS IMPORTANT TO EVALUATE THE QUALITIES OF LIGHT SO THAT YOU CAN PROPERLY USE IT.

defined or demonstrated. Just a few examples are twinkle lights; light from a projector, computer screen, or a tablet; and car headlights. With these sources, as with those discussed previously, it is important to evaluate the characteristics of the light—quality, direction, intensity, and color—so you can properly use it. Once you've evaluated these characteristics, it should be easy to decide how you will use the light in your photograph.

CANNED LIGHTS: WHY THEY ARE NOT OUR FRIENDS, PART 1

I hate canned lights. As a documentary photographer, I try to not interfere with the action, and I record events as they unfold. Unfortunately, it always seems that the best moments occur under a canned overhead light. These lights cause horrible, unflattering shadows. If you cannot change locations or turn the lights off, use additional light or have your subject take a few steps back. By positioning the subject at the edge of the cone of light, the light falls on him or her at an angle, not from directly above. While it might not be the best light, it is a vast improvement.

Left—Notice Shannon's "raccoon eyes"; this is due to the canned light right above her. **Right**—Moving her back to the edge of the light caused the light to fall on her face at an angle and improved the shadows.

There's always an exception to the rule. The canned lights in this stairwell perfectly lit Ali and Matt because I was able to get above them and have them turn their faces toward the light. Nikon D3, 24–70mm, f/2.8, $^1/_{125}$ second, ISO 1600.

4. Modifying Available Light

REFLECTORS

A reflector is any material that reflects light back onto a subject. A professional photography reflector comes in a variety of sizes and has a flexible frame that allows you to fold it down to a more portable size. You can also use something as basic as a piece of white foam core board to bounce light back onto your subject.

Reflectors are most commonly available in white, silver, and gold. White and silver reflectors will generally bounce back a neutral-colored light. Silver reflectors tend to give a bit more specularity to the light. Like any of its metallic counterparts, a silver reflector tends to have a bit more strength or intensity than a matte white reflector.

Gold reflectors give the light a warm color cast. Therefore, they can help you to match the existing light when working at sunset.

Reflectors, a scrim, and a flag.

Below—Using a reflector added light to the couple's faces and directs the viewer's attention to them in the photo. The image without a reflector is shown on the left. The image with the reflector is shown on the right.

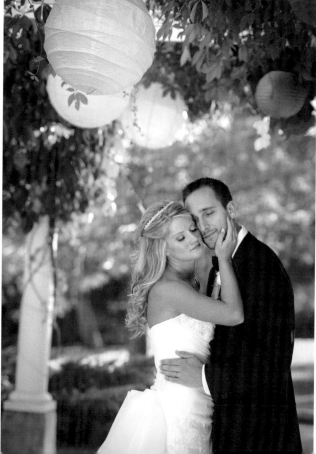

We don't use gold reflectors for our everyday portraits because it can make our subjects' skin look too warm and produce too much mixed-color lighting when we are trying to fill in blue shadows.

The size of your reflector does matter. A 12-inch reflector will reflect back a much smaller spread of light than a 36-inch reflector. The larger reflector will cover a larger area with reflected light. The larger light source means you'll have softer light.

Why Do You Use a Reflector? There are three main reasons to use a reflector:

- to add light to a scene or provide more direction to the light
- to provide fill light to illuminate shadows
- to provide fill light to control shadow contrast

How Do You Use a Reflector? Reflectors are easy to use because what you see is what you get. When you use your reflector as a main source of light, remember that you have to treat it like any other light source and think about the intensity, direction, quality, and color of the light.

The actual intensity of the light bounced back onto the subject depends on the intensity of the source light hitting the reflector and the distance of the reflector from the subject. Metallic reflectors will bounce back more light than matte white reflectors.

Reflected light from direct sunlight can be a bit intense and harsh on your subject. To control the intensity, you can "feather" the light. To do so, simply direct the light past your subject, then turn it slowly back onto your subject until you have the intensity that you want.

Where Do You Position Your Reflector? Many photographers find a bit of light to reflect onto their subject and don't think much about the direction it is coming from. As we discussed in the previous section, light has direction, and some directions of light are more attractive for portraits than others.

We used a white (top), silver (center), and gold (bottom) reflector as a fill light on Shannon. Notice how the silver and gold metallic reflector bounced more light back onto her. Notice also how the gold reflector reflects warm-colored light, while the white and silver reflectors reflect much more neutral-colored light.

Direct Sunlight. It is easiest to catch the light with a reflector by holding it down near the ground and reflecting light up onto your subject. However, if you are using the reflector light as your main light, this will create "ghoul" lighting—unattractive light that should be avoided when possible. While it takes much more work, it is best to have your assistant hold the reflector overhead and direct light down onto the subject. This will better mimic the look of natural sunlight and provide more attractive lighting patterns.

Top right—Without reflector. **Left**—With reflector. Notice how reflecting light back onto her warmed up her skin tones and improved the quality of light. **Bottom right**—For comparison, here is the direct sunlight photo. The light was so bright, Tabitha couldn't keep her eyes open.

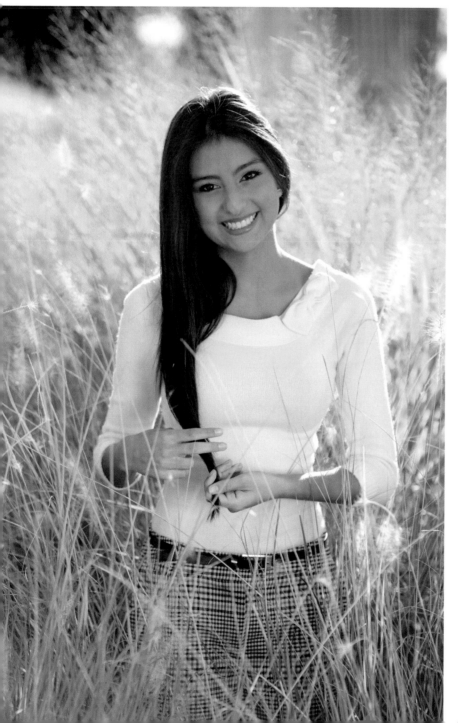

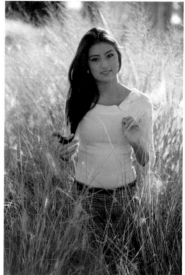

Due to the overcast skies, Shary's eyes are dark and dull (left image). Reflecting a little bit of light onto her from below makes her eyes sparkle. Be careful when you position your reflector. In the first photo (center image), we completely filled in the shadow below her chin. The shadow under the chin helps shape the face and makes people appear slender. By angling the reflector outward slightly, we were able to light her eyes and maintain a bit of shadow under the chin (right image). The pull-back image shows the reflector position.

Open Shade. As we discussed earlier, even in open shade, diffused light comes from above. While never as ugly as the eye-socket shadows caused by overhead direct sunlight, the overhead light can cause the eyes to appear dark and dull. By placing a reflector below the subject's face, you can bounce just enough light back into the eyes to make them more attractive and lively. The purpose of the reflector is to fill in the shadows, not to serve as the main source of light.

Window Light. A reflector is a great tool for controlling the contrast in the image. When working with directional window light,

sometimes the light has too much contrast, meaning that to properly expose for the highlights in the photos, the shadows go very dark and don't reveal much detail. By adding a reflector opposite the main light and parallel to the subject, fill light opens up the shadows on the unlit side of the face.

SCRIMS AND DIFFUSERS

A scrim or diffuser is used to diffuse the light in your scene and change the quality of the lighting. A scrim is a piece of diffusion material that is attached to a frame. It is placed between the light source and the subject. Light is still able to pass through the scrim, but the intensity of the light hitting the subject is decreased, resulting in a softer light. Scrims are available in varying levels of opacity that allow different intensities of light to pass through.

How Do You Use a Scrim? If you are in harsh direct sunlight with nowhere to move, a scrim or diffusion panel will do wonders to soften the light and create much more flattering lighting patterns on the subject. Simply place it between the subject and the sunlight. Because it does allow light to pass through, the light will still have direction. If the light is coming from above, placing a scrim above your subject means the light is much more diffused and softer, like open shade.

In open shade, you might need to use a reflector to bounce a little light when using a scrim overhead to reduce the contrast and harshness of direct sunlight.

GOBOS AND FLAGS

Sometimes it's not so much where the light is as where the light isn't that matters most. The purpose of both gobos and flags is to block light. Nowadays, the term *gobo* usually refers to a modifier used to produce patterns of light and shadow. The term *flag* is more commonly used to refer to a modifier that blocks light. A flag can be made from any number of materials—from fabric stretched across a frame to foam core board.

When Do You Use Gobos or Flags? In direct overhead light, we may use a flag or gobo above our subjects to create cover shade. By using a non-transmissive flag instead of a scrim, we can ensure there is no light hitting the top of the subject. This makes all the light come from the front and gives it more direction.

Top—This window light image was made without fill. **Bottom**—Here, we used a reflector as a fill source.

We did a couple of different photos for Dee—one without a scrim (top left) and one with a scrim (bottom left). The scrim is placed between her and the sun. Notice how the background becomes lighter. The scrim cuts down on the light reaching your subject, so your subject will appear darker. Because the scrim only covers a limited space, the background exposure will not change. As you increase the exposure on your subject, you are also increasing the exposure on the background. This will make it appear brighter than in the photograph without the scrim. The right photo shows the finished, cropped portrait.

We can also use a flag to control the spread of light. If we have a large window, for example, and we want a sliver of light to illuminate just the subject, not the rest of the room, we can use something to block that light. In this case, a set of curtains could become a flag.

Gobos in the more current sense are used to create interesting patterns of light and shadow in the scene or across the subject.

Often we see them used to project a pattern or someone's name on a floor or wall at a wedding reception.

Objects in a scene we're photographing can often act as a gobo. For example, light passing through a set of blinds can create an interesting pattern of light and shadow—and those lines could serve as leading lines in the composition.

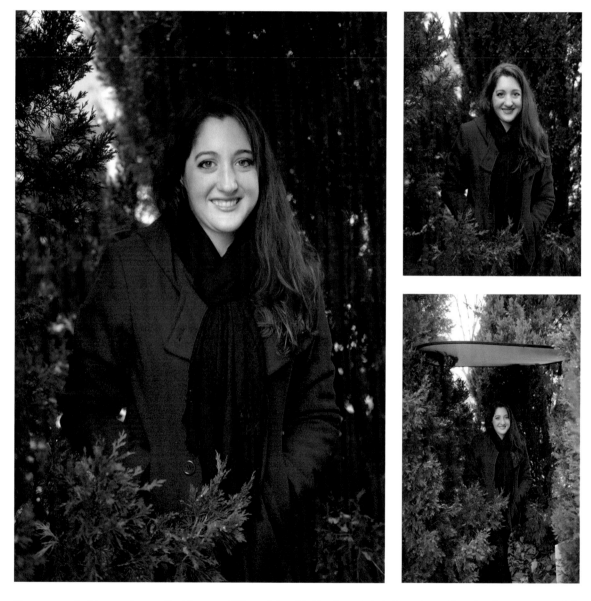

The overcast skies made our first image of Meredith a bit flat (top right). By using a flag (in this case, a solid reflector that blocked the light coming from above), we were able to make the light come from in front of her, rather than from above. Notice how her eyes are much more brilliant in the photo made with the flag (above). The pull-back shot (bottom right) shows the position of the flag.

CREATING AND MODIFYING THE LIGHT

We've discussed some ways to get the most out of your available light and confront some of its challenges. But what do you do if the quality of light on location is just really poor? Or more importantly, what do you do if there is no light at all? Your only choice is to create the light you need to get the look you want for your photographs. In this section, we'll discuss the three most common forms of artificial light: video/constant lights, hot-shoe flashes, and studio strobes.

As we stated at the beginning of the book, we want to teach you how to use the tools you'll need to work on location without being dependent on the surrounding amenities—including access to electricity. So while there are a lot of different lighting tools out there, we have decided to fo-cus on battery-operated lights. Battery-operated video lights, hot-shoe flashes, and studio strobes give you much more freedom to go wherever you want to go on location and give you creative lighting freedom. The photography techniques that we demonstrate here are the same no matter if you use batteries or plug your lights into an outlet.

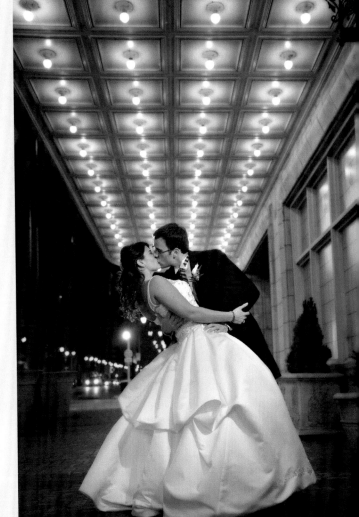

For this romantic photo, we used a video light to supplement the light falling on Molly and Adam. Nikon D700, 24–70mm, f/2.8, ¹/₆₀ second, ISO 1600.

5. Video Lights

M any people who are new to working with artificial light like constant lights because they allow you to see where the light is falling and what shadows will be cast on the subject while photographing. It truly is a what-you-see-is-what-you-get lighting solution. Constant light sources (e.g., video lights) have a distinctive look compared to flash. They can be quite dramatic when used properly. But you should note that their quality of light differs among each brand and model due to the power level, shape, and size of the unit.

There are many different lights on the market at a range of prices. In this book, we will discuss the constant light sources most often used by photographers—halogen video lights and LED lights.

VIDEO LIGHTS: HALOGEN VERSUS LED

Halogen video lights, like the Lowel ID-Light, are a popular battery-powered light among wedding and event photographers. The light is tungsten color balanced and features the ability to focus the light. Except for the top-of-the-line LEDs, most LED lights do not have a way to focus the spread of light. The Lowel ID-Light has several different accessory options, including barn doors to control the spread of light.

One thing that we really like about the Lowel ID-Light is its nice spotlight effect and a beautiful feathered edge of the light. It gives a very dramatic look to the lighting and allows us to create our signature classic Hollywood-style portraits.

A couple of the disadvantages of the halogen lights are that they tend to run hot and their battery power does not last as long as LED lights. LED lights are also much more compact and easier to transport than most halogen lights. While the Lowel ID-Light and other halogen lights might have a greater intensity than many LED lights, they cannot compete with daylight and are best used indoors or at night.

We created this Old Hollywood style portrait with two LED flashlights, one lighting Liam from camera right and the other lighting Nicole from camera left. Nikon D3s, 24–70mm lens. Exposure: f/2.8, $^1/_{125}$ second, ISO 1600.

Facing page—This elegant photo of Jabeen in her wedding attire was lit by a Lowel ID-Light—a halogen video light. Nikon D3, 70–200mm, f/2.8, $^1/_{100}$ second, ISO 1600.

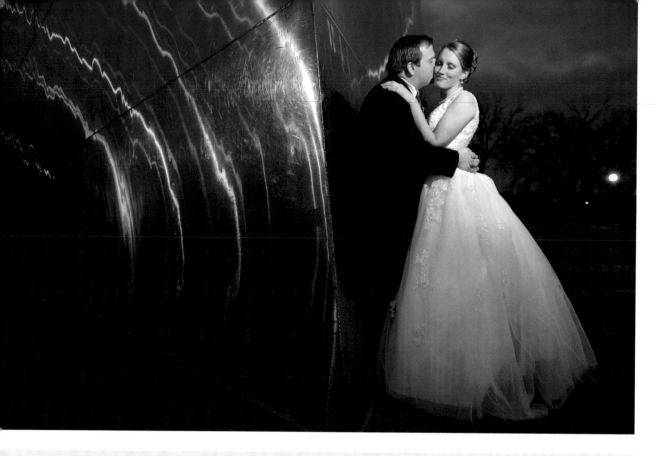

BATTERY BASICS

While some video lights and battery-powered studio strobes come with their own proprietary batteries, most LED lights and hot-shoe flashes are powered by AA batteries. It is important to note that not all batteries are created equal, and there are several factors you'll want to take into consideration when choosing what to buy.

How much do the batteries cost? Single-use alkaline batteries will cost less initially than rechargeable batteries, but rechargeable batteries will quickly pay for themselves. There is also the environmental cost to consider. Most batteries end up in landfills leaking toxic sludge. Rechargeable batteries help keep a few more batteries out of our landfills.

How long will the battery stay charged? No battery will stay charged forever. It's important to know how long the batteries will hold their charge. Some rechargeable batteries start losing their charge within 24 hours of being charged, even when they are not in use. Other batteries will hold their charge for a long time, but that can affect their performance.

How much capacity does the battery have? Capacity relates to how many flash exposures you can get out of a set of batteries. High-capacity batteries deliver on performance but do not hold their charge for very long. Conversely, long-life batteries hold their charge for a long time but have less capacity.

What are the recycle times for the batteries? You want a battery that will be able to deliver power to the capacitor at a speed that will allow your flash to recycle at speeds consistent with your shooting style.

How hot do the batteries get? Heat is the enemy of any electrical product. If your batteries heat up too much when they discharge energy, they could cause damage to the electronics of your flash. The more rapidly the batteries discharge, the hotter they will get.

There are three main types of AA batteries: single-use alkaline, single-use lithium, and rechargeable nickel-metal hydride (NiMH).

SINGLE-USE BATTERIES

Single-use batteries come in two types: alkaline and lithium. The benefit of the single-use alkaline batteries is that they can be purchased almost anywhere—from gas stations to department stores. Alkaline batteries are relatively inexpensive and have a long shelf life. There is a difference in performance between the different brands of alkaline batteries. As with many things, you get what you pay for.

Alkaline batteries work fine in a pinch, but as you start demanding more power and performance out of your flash, you will want something with higher capacity and better recycle time.

Lithium batteries have several benefits. They have a long shelf life (they hold their charge), operate in almost every climate, and are almost half the weight of normal alkaline batteries.

Unfortunately, because of their long lifespan, lithium batteries lose some of their ability to deliver power quickly. They are also more expensive than alkaline batteries. However, if you choose to go the route of rechargeable batteries, it is a good idea to keep a set of lithium batteries in your bag. If your rechargeable batteries aren't charged, the lithiums will be at the ready.

Facing page—When we set our white balance to tungsten to match the warm color temperature of the video light, the ambient light became much bluer. Nikon D3, 24–70mm, f/2.8, $1/60$ second, ISO 800. **Right**—Single-use alkaline batteries, single-use lithium batteries, and rechargeable nickel-metal hydride (NiMH) batteries.

We often use LED lights in our studio. They are a great option for a daylight-balanced constant light source. They are portable, very energy efficient, cool to the touch, and many models feature dimming and color-balance output controls that allow you to switch from tungsten to daylight color balance. If they do not come with a color balance switch, many will include a tungsten filter to attach over the light.

There is a difference between the least expensive and higher-priced units. Besides being better built and more durable, the higher-end models have more accurate and consistent color balance. Products like LitePanels and the Westcott Ice Light boast true 5500K daylight white balance. The cheaper LEDs we've used have had a slight green cast, which isn't kind to skin tones.

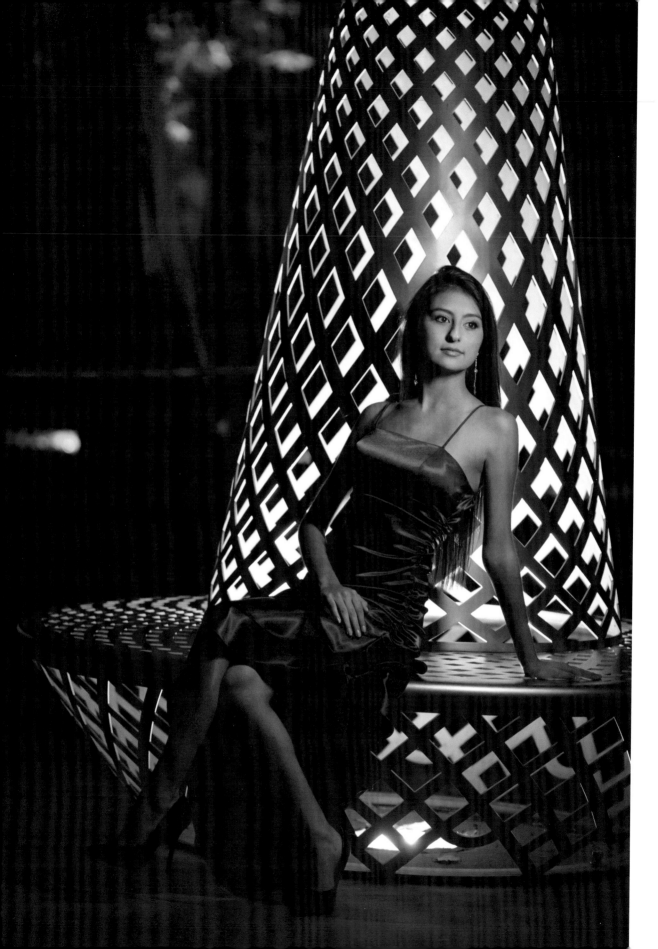

Above—Photo of Lowel ID-Light.
Top right—Photo of LED video light. **Bottom right**—Photo of the Westcott Ice Light.

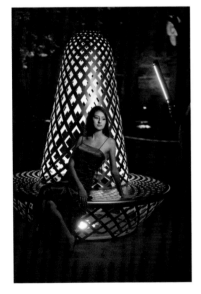

Facing page—The Westcott Ice Light creates a soft, even strip of light like window light. Like many video lights, it doesn't cover a great distance and needs to be used fairly close to the subject. **Above**—The pull-back shot. Nikon D3, 70–200mm, f/2.8, $^1\!/_{125}$ second, ISO 1600.

LED lights are a collection of many tiny LED bulbs. You'll find them in all shapes, sizes, and intensities—anything from a 4x6-inch rectangular light, to a 2x20-inch strip light, to a 4-inch diameter round light and 63 to 94 watts. While each will have a different spread of light due to its shape, the nice thing about LED lights is that there is a consistent intensity across the entire illuminated area. There are no hot spots like you can sometimes experience with halogen video lights.

Like halogen video lights, one of the drawbacks to LED lights is that most models (excluding the large professional models, like those used in television studios) are not very powerful and need to be used in relatively close proximity to your subject. They are best put to use indoors or at night.

How Do You Use a Video Light? The nicest thing about constant light sources is what you see is what you get. You simply need to move your light to get the lighting direction and pattern that you want.

RECHARGEABLE BATTERIES

Rechargeable batteries are a great option for people who regularly use their flashes. They deliver the high capacity and quick recycle times that your flash needs. And while they might be more expensive at the outset, they are less expensive in the long run.

The only negative to rechargeable batteries is that they self-discharge. In the first 24 hours after charging, they can discharge up to 10 percent of their capacity and an additional 1 percent each day afterward. So it is important to charge them as close to when you will use them as possible.

If you don't have the ability to charge your batteries right before a session, consider purchasing low-discharge nickel-metal hydride (LD-NiMH) rechargeable batteries. They have a slightly lower capacity than regular NiMH batteries, but they will hold up to 80 percent of their charge for up to a year.

Another thing to consider with rechargeable batteries is that they are not indestructible and have a limited life. Most of the manufacturers set something on the order of 1000 recharge cycles as the lifespan for their batteries. In practice, when dependability is key during heavy, very stressful use (i.e., with a flash), it is wise to change them more often. Normally, we rotate batteries that are over a year old to less stressful and less vital roles. Also, it's advisable to get a charger or other device that notifies you when there is a problem with a particular battery, so that you can refresh it or remove it from use so it doesn't fail at an important moment.

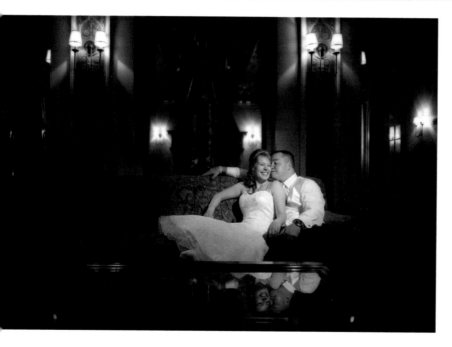

We gelled our LED video light with a $1/2$ CTO gel so that the color temperature of its light better matched the color temperature of the tungsten lights in the background. Nikon D3, 24–70mm, f/2.8, $1/60$ second, ISO 1600.

The images and captions that appear on pages 83 and 84 show the setup and thought patterns behind a few of our video light photographs.

I wanted it to seem that Alicia was lit by the lamp in the scene, not a video light. In these images, you see the different effect produced when a CTO-gelled square LED light is used (top) versus a round halogen spot video light (bottom). Besides the size of the area covered, you'll note that the halogen light created an obvious hot spot and the LED light is much more even. Nikon D3s, 50mm, f/2.5, $^1/_{125}$ second, ISO 1600.

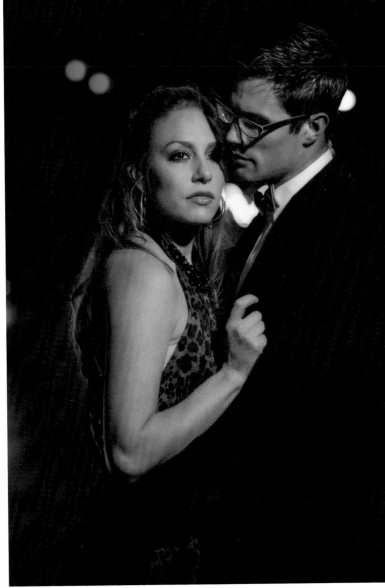

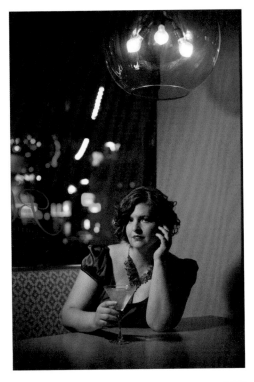

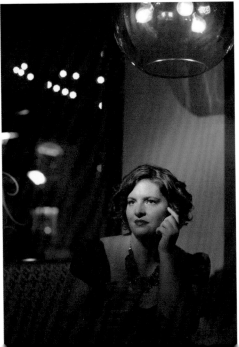

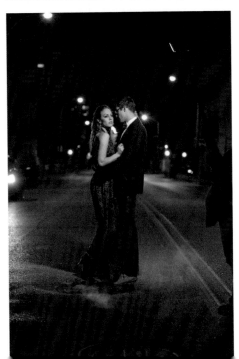

Above and left—I wanted the light to come from fairly high above the subjects so that it would mimic streetlights. We put the video light on a monopod so it could be held higher and had an assistant shine it on the woman's face. I used my car's headlights to provide subtle rim light on the back of her arm. The pull-back image shows the setup. Nikon D3s, 85mm, f/2.5, $^1/_{80}$ second, ISO 1600.

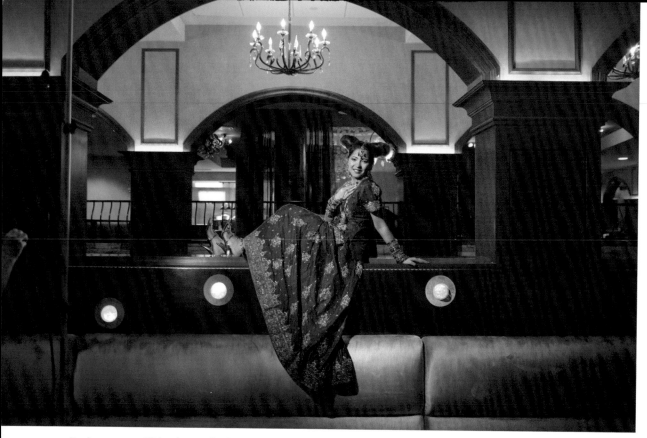

Facing page—This photo of Jabeen in a hotel lobby in Dallas was lit with three different video lights—a Lowell ID-Light on a stand to illuminate her face, a small halogen spotlight to light her shoes, and an LED from behind providing just a bit of rim light on her arm. Nikon D3, 24–70mm, f/2.8, $^1/_{125}$ second, ISO 2500. **Above**—The pull-back shot.

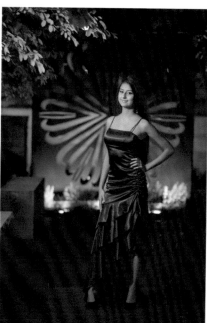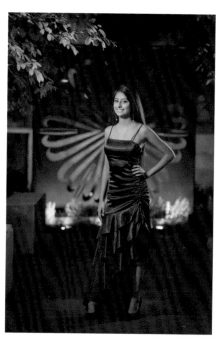

Here are a trio of images of Tabitha. The first (left) was made using available light only. In the second photo (center) the Westcott Ice Light added nice, soft light to this nighttime photo. For the third image (right), we added a second light as a rim light behind her; this resulted in better separation from the background. This makes the image pop. Nikon D3, 70–200mm, f/2.8, $^1/_{125}$ second, ISO 1600.

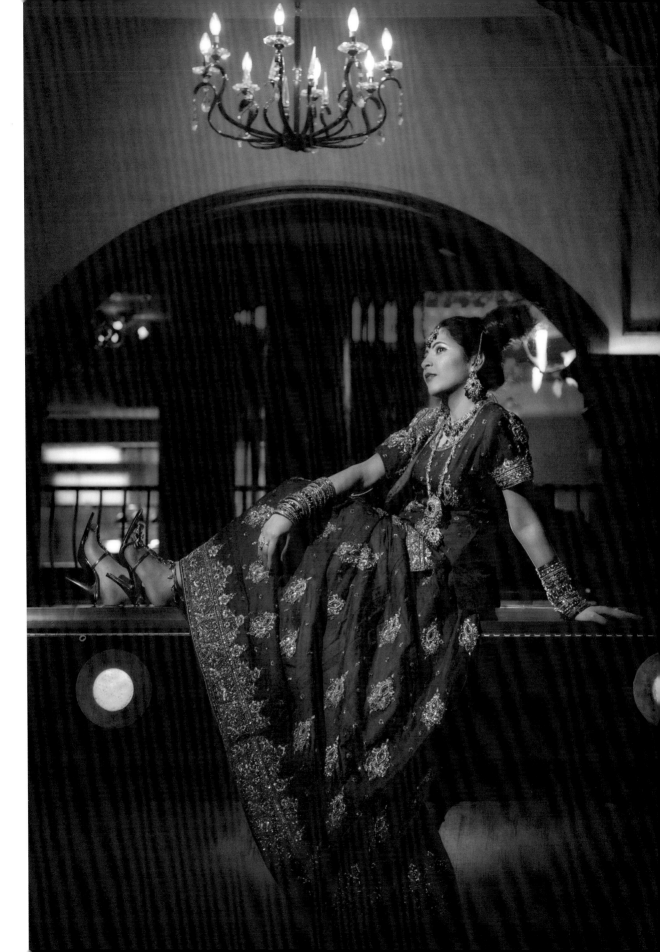

6. Flash

Flash photography can at times be intimidating to photographers. Direct on-camera flash is often flat, hard light that is rarely flattering. If the flash unit doesn't have a modeling

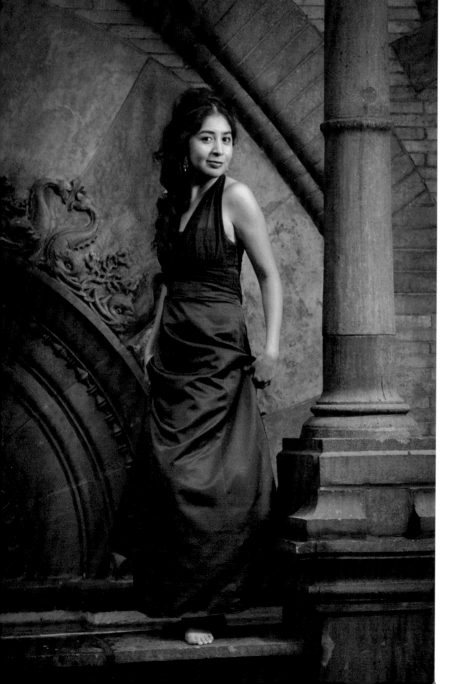

■ **THE BEST FLASH PHOTOGRAPHS LOOK LIKE THEY WERE MADE WITHOUT FLASH.**

When you look at this photo, you should see a beautiful woman. You don't want your viewer to think "Wow! They sure used flash in that photo." Flash lighting should be subtle and add to the photo; it shouldn't be obvious or distracting. This photo was taken at dusk. It was lit by a flash in a softbox, triggered by the PocketWizard Flex system in TTL mode. Nikon D3, 70–200mm, f/3.5, $^1\!/_{125}$ second, ISO 400.

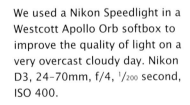

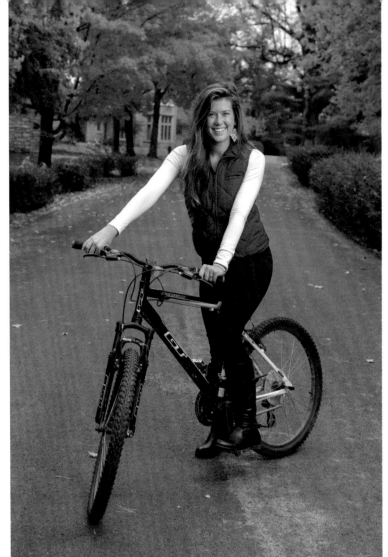

We used a Nikon Speedlight in a Westcott Apollo Orb softbox to improve the quality of light on a very overcast cloudy day. Nikon D3, 24–70mm, f/4, $^{1}/_{200}$ second, ISO 400.

light (e.g., hot-shoe flash), you don't have that "what you see is what you get" crutch that you have with daylight or video lights. But with practice and an understanding of how different techniques affect the look of your photography, flash photography can become a powerful tool for you to use on location.

There are a few things to watch out for when using flash. Usually, the best flash photographs look like they were made without flash. The flash should be used to highlight the subject and add drama, depth, and dimension; it should not be the focus of the image. To fully achieve this goal, it is important that your flash has the same direction and color as the ambient light.

When shooting in sunlight, a telltale sign that the subject was lit by flash is shadows falling in multiple directions. There is only

The bluish tone of the flash is distracting in the photo above. It is a telltale sign that a flash was used. By gelling our flash with a $^1/_2$ CTO gel, we were able to match it to the color temperature of the existing light and make it look like the photo was made with available light only (left).

one sun in the sky, so the shadows should fall only in one direction. There may be times when you want to cross-light the subject for effect, but if you want your flash to look natural, it's important to keep the shadows in mind. The direction of the shadows should match those of the ambient light. Long shadows indicate that it is early or late in the day, and short shadows mean it is midday.

Another thing that can draw attention to the fact that you used flash is if the color of the flash and the ambient light do not match. The flashes naturally have a color temperature of about 5500K, which is about the same as midday sun. But when shooting closer to sunset or indoors in tungsten lighting, the ambient lighting will be much warmer (2500–3800K) than the light your flash

■ **THE DIRECTION OF THE SHADOWS SHOULD MATCH THOSE OF THE AMBIENT LIGHT.**

produces, and the light from the flash will appear blue in comparison. It is very difficult to correct for mixed lighting colors. The best way to deal with different color temperatures is to gel your flash to match the ambient light.

STUDIO STROBES VERSUS HOT-SHOE FLASHES

For our style of photography, we value flashes that are lightweight, portable, and easy to set up. For our weddings, we like to be able to carry all our equipment ourselves and not be loaded down by multiple bags. We're Nikon users, and we love the features the Nikon Creative Lighting system offers, including i-TTL technology and their Advanced Wireless System. Because of that, we favor and extensively use hot-shoe flashes in most of our wedding work.

However, for some portraits, we like to use a battery-powered studio strobe. It has two main advantages over the hot-shoe flash: it is much more powerful and has a modeling light. Because it

■ **WE VALUE FLASHES THAT ARE LIGHTWEIGHT, PORTABLE, AND EASY TO SET UP.**

We regularly use hot-shoe flashes because they are light and easy to carry—even when you have to hike out to a location for a photograph.

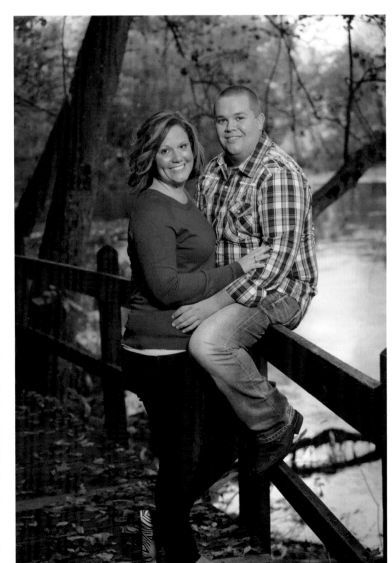

We needed a lot of power to match the bright sun at the ocean, which made the Profoto Acute B2 a useful tool. Nikon D3, 70–200mm, f/16, $^1/_{250}$ second, ISO 100.

Photo of Profoto AcuteB2 system.

■ IF YOU HAVE NEVER WORKED WITH STUDIO STROBES, THEY MIGHT SEEM A LITTLE INTIMIDATING AT FIRST.

is more powerful, we can overpower the sun with it and can use larger modifiers (like softboxes) to create a softer quality of light.

Studio Strobes. If you have never worked with flash before, let alone studio strobes, they might seem a little intimidating at first. But once you get the basics down, you'll have a lot of freedom to create photos, no matter what lighting situation you might face.

■ STROBES ARE EASY TO USE AND OPERATE SIMILARLY FROM BRAND TO BRAND.

There are a few things to remember about working with studio strobes. They are manual flashes, so you will have to set your camera exposure to manual mode. For all practical purposes, you cannot fire your studio strobe above the maximum camera sync speed. For most cameras, the maximum sync speed is $\frac{1}{200}$ or $\frac{1}{250}$ second.

Strobes are generally pretty easy to use and operate similarly from brand to brand. The most important thing is to know the location of the on button, the power setting button, and the sync socket (means of triggering the flash). Many studio strobes will start at MAX or $\frac{1}{1}$ power and then give you fractions of power output to choose from. There is a one-stop exposure difference between each of the following power outputs: $\frac{1}{1}$, $\frac{1}{2}$, $\frac{1}{4}$, $\frac{1}{8}$, $\frac{1}{16}$, and $\frac{1}{32}$.

HOW TO USE A LIGHT METER

Light meters are a valuable tool when working with studio strobes or any manual flash. We highly recommend buying one. While you could set up your lights, take a photo, chimp the back of your camera, and then adjust and adjust again to get it right, a light meter will give you an accurate and precise reading immediately. Not only does this save you time, but it also allows for repeatability. Light meters allow you to create precise lighting ratios. The newest generation of light meters (like the Sekonic Litemaster Pro L-478 series) can control your flash output and even make sure your hot-shoe flash exposures are within the dynamic range of your camera.

To use your light meter:

1. Set the light meter to flash metering mode.
2. Input your camera's shutter speed and ISO on your meter.
3. Place the meter where the light will hit your subject. Make sure that the meter's dome faces your camera.
4. Trigger your flash.
5. Read the measured f-stop and set your camera accordingly.

Right—Proper placement of a light meter to get an accurate reading. **Below**—Photo Sekonic Litemaster Pro L-478.

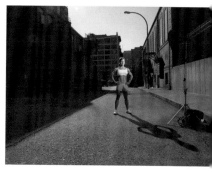

The sun was already intense for these early-morning fitness photos of Diana. I took a few photos of her facing the sun (top image) but decided that I wanted to use a darker background to draw more attention to her. I turned her around, used the sun as a hair light, and metered to underexpose the background. I used the Profoto AcuteB2 in a beauty dish for the final image (left), as you can see in the pull-back photo above. Nikon D3, 24–70mm, f/16, $^{1}/_{250}$ second, ISO 100.

We use a Profoto AcuteB2 600 system. We like the Profoto not only for its incredible quality of light but also for its reliability and quality build. The AcuteB2 system (B stands for battery) allows us to make 160 full-power exposures (or 600 at $^{1}/_{4}$ power) on one full battery charge. The unit is powerful and lets us overpower midday sun, even with a large softbox attached to it.

To determine your power output for correct exposure, you can examine a test shot on your camera's LCD and confirm the exposure with your histogram or light meter. Sure, checking the LCD screen will get you close and can work in a pinch, but using a light meter is the best way to get a proper, precise exposure reading.

To trigger your flash, you will need to use a sync cord or some sort of wireless trigger system. To be honest, it's been many years since I've used a sync cord. They're cumbersome and limit your mobility, and I don't like to be tied to anything. Wireless triggers are the way to go. We use the PocketWizard system. It is an extremely reliable and durable system, and in many ways it has become the industry standard for wireless triggers.

■ USING A LIGHT METER IS THE BEST WAY TO GET A PRECISE EXPOSURE READING.

A beauty dish on the Profoto AcuteB2 provided a beautiful quality of light for this portrait of Sutton. The pull-back shot below shows the light setup. Nikon D3s, 24–70mm, f/8, $1/60$ second, ISO 200.

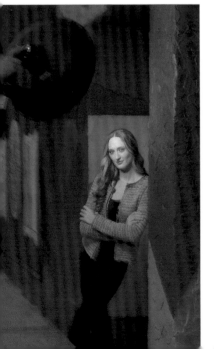

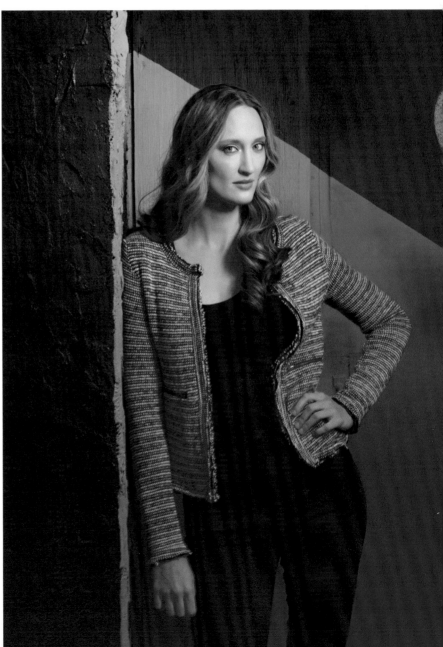

To fire your off-camera flash wirelessly, you will need to have a transmitter on the camera and a receiver on the flash so that your camera and flash sync properly. We use the PocketWizard Plus III transceivers on our cameras. The Profoto system has an option to purchase the PocketWizard receiver installed in the unit.

Studio strobes are built with the idea that you will be using them with modifiers like umbrellas, softboxes, and beauty dishes. In the next chapter, we discuss all the different modifiers available and will describe how they affect your light.

Hot-Shoe Flashes. *Note:* Entire books have been written about hot-shoe flashes and how to operate them, including Stephanie's book, *Nikon® Speedlight® Handbook,* published by Amherst Media®. Since there is so much to be written about hot-shoe flashes and so much varies from one camera manufacturer to another, this book will just focus on the techniques you need to get the most out of hot-shoe flash units on location. For specific settings and how to operate them, be sure to read the flash's user manual and check out some of the other available brand-specific guidebooks.

Nikon SB-910.

Canon 600 EX-RT.

FLASH MODES

Different flash manufacturers offer different flash modes on their units, but the most common and useful are manual and TTL mode. Here is a brief overview of the two modes.

Manual Mode. When working in manual flash mode, you get to choose the flash power output and the aperture. You are completely in control of what the outcome will be. The power levels of most quality flashes range from $^1/_1$ (full power) to $^1/_{128}$ power. In manual mode, aperture and distance affect flash exposure. The nice thing about manual flash is that it guarantees repeatable flash exposure from frame to frame. The downside is that if your subject distance changes or you change your aperture, you also have to manually change your flash output level.

TTL Mode (i-TTL for Nikon and e-TTL for Canon models). TTL is the most automated and the most advanced of the flash modes. It works by evaluating the flash exposure and then automatically setting the flash to the proper power level.

Current TTL technology works by firing pre-flashes to help determine the proper exposure. Pre-flashes are fired almost simultaneously with the main flash, which makes them nearly

■ **IN MANUAL FLASH MODE, YOU CHOOSE THE FLASH POWER OUTPUT AND APERTURE.**

undetectable. The light from the pre-flash is reflected off the subject, travels through the camera's lens, and is measured by the meter in the camera. The camera combines the information from the pre-flash about the scene's available light and shadow areas, subject distance, reflectance, and color temperature with information about the aperture, ISO, and lens focal length to tell the flash at what power it should fire.

TTL MODE IS USEFUL WHEN YOU ARE WORKING IN DYNAMIC SHOOTING SITUATIONS.

TTL mode is useful when you are working in dynamic shooting situations where the distance between the subject and your flash is constantly changing, like at a wedding.

FLASH TECHNIQUES

Besides getting a correct exposure, you also need to use the proper technique to get the results you really want with flash photography.

Direct On-Camera Flash. Direct on-camera flash is probably the most common technique for those who are new to using a flash. All it requires is attaching your flash to your camera, turning on the flash, pointing the flash directly at the subject, and firing.

The trouble with direct on-camera flash is that it doesn't produce very attractive lighting. Because the flash is a relatively small light source it produces harsh, well-defined shadows. The light comes from the same axis as the camera, so it is flat and undefined. Also, if you are photographing people with a telephoto lens, you have a greater chance of getting red-eye in your photographs.

Both of these photos were taken with flash pointed directly at the subject. The first one (left image) shows direct on-camera flash. The light is flat, and the shadow behind Baruc's head is distracting. By taking the flash off camera (45 degrees camera right), we were able to create more interesting and pleasing light (right image).

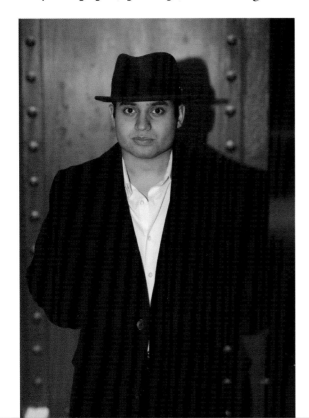
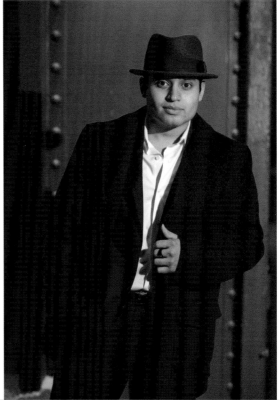

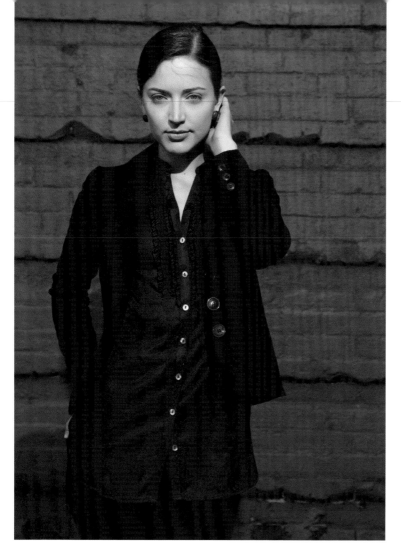

We were able to mimic the sunlight by using a direct flash off camera. One benefit of using the flash instead of the sun is that your model doesn't squint like she would in direct sun (see image above).

That being said, skillfully applied direct off-camera flash can create very interesting and dramatic photographs. The flash is a relatively small point of light, so you will have well-defined shadows, but being able to move the flash around will allow you to determine where the shadows fall. This will define the shape, depth, and dimensions of your subject.

Fill Flash. When photographing a portrait outdoors in shade or when the background is lighter than your subject, you will probably want to provide a little fill flash to open up deep shadows and add catchlights in the eyes. When working in deep shade in auto white balance, providing a bit of fill flash will also warm up the scene.

Many flashes have a mode that does a good job of balancing the flash with the ambient light, but even in that mode, you may want

■ **MOVING THE FLASH WILL ALLOW YOU TO DETERMINE WHERE THE SHADOWS FALL.**

to reduce the exposure compensation value a little. The goal is to get a kiss of light, but not make it look like a flash was used.

Bounced Flash. One of the most valuable features of Nikon and Canon flashes is that they have a rotating flash head. This

This image was shot without flash fill.

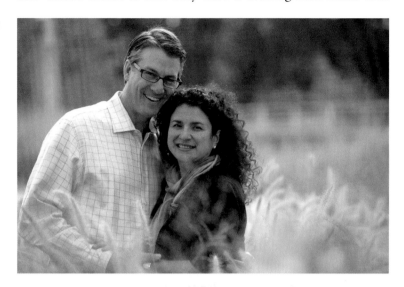

Notice how a little fill flash not only warms up Tim and Ellie's skin tones but also fills in any distracting shadows on their faces and allows us to control our background exposures better.

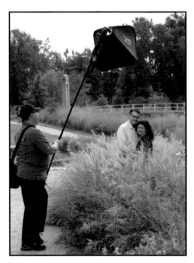

The pull-back photo shows the setup.

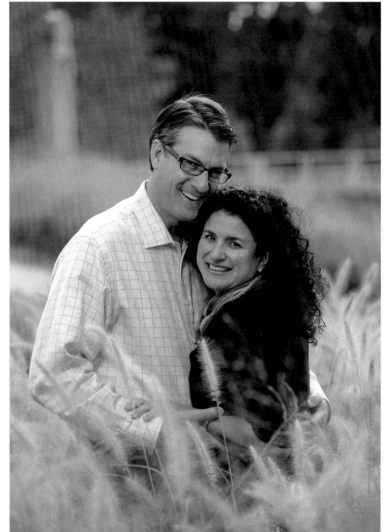

allows us to bounce our light off of walls, ceilings, or practically any surface that is not too far away.

Learning how to properly bounce your flash is an important skill for anyone who works with on-camera flash. As we've already shown in the previous examples, on-camera direct flash is not very flattering—it's flat and harsh lighting. Bounce flash, on the other hand, allows us to light our subject with soft, directional lighting.

Here, you can see the difference between direct flash, bouncing directly behind, bouncing to the right, and bouncing to the left. Notice the different lighting patterns and the direction of light on Shannon's face.

CANNED LIGHTS: WHY THEY ARE NOT OUR FRIENDS, PART 2

Remember how I said I hate canned ceiling lights? Even with flash, they can be tricky to deal with. At this church, there were strong overhead canned lights up and down the entire aisle. No matter where I moved the bride and bridesmaids, they seemed to be directly under them. The light cast horrible shadows on their necks (as you can see in the unlit photo). I was stuck trying to balance the ambient light of the altar and trying to overpower the canned lights with flash, all in a matter of minutes before the ceremony. I reached an acceptable balance, but you can still see a slight shadow on the bride's neck.

Left—Photo without flash. **Right**—Photo with flash.

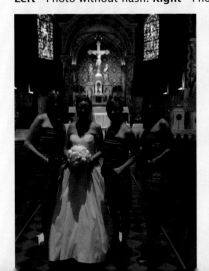
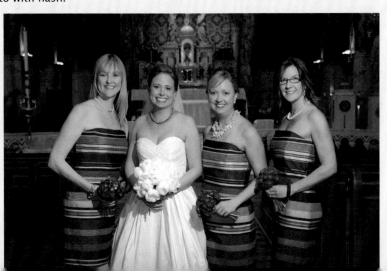

Bounced flash let me freeze the action of these kids bouncing on the bed, keep the light soft and directional, and not have to bring in a lot of extra equipment that might distract the kids. Nikon D3, 24-70mm, f/4, $^1/_{125}$ second, ISO 400.

However, good bounce lighting is more than just directing the flash in some direction away from the subject. Many photography books will suggest that you tilt your flash 45 or 90 degrees and bounce its light off the ceiling. While this will soften the light and make it more flattering than direct flash, it falls short of taking full advantage of the lighting possibilities of bounce flash. To truly master bounce flash, it's a good idea to understand the angle of incidence and reflection and classic lighting patterns and positions.

The angle of incidence of light is the same as the angle of reflection. The angle of incidence is the angle at which light hits a surface. The angle of reflection is the angle that the light is reflected or bounced off a surface. Knowing this, we can carefully choose where we bounce our flash to create all kinds of lighting patterns and effects.

It's best to think about the surface you will bounce your light off of as the light source rather than the flash itself. You can almost think of walls and ceilings as giant softboxes. By bouncing the light off a wall, you make the relative light source (the wall) much larger than just the flash head and therefore create much softer light. With that in mind, it's useful to think, "If I had a softbox with me, where would I place it?" Once you have that in mind, bounce your flash toward where you would have placed a softbox.

There are a couple of things to keep in mind when working with bounced flash. You will generally lose a couple of stops of light depending on the subject distance, the bounce distance, and the color and reflectivity of the surface you are bouncing the light off of. While TTL and auto modes will compensate for this loss of light, you may still find yourself increasing the flash exposure compensation to get a proper exposure.

This tender moment would have looked horrible with just the available light coming from above. I chose to bounce my flash to not only fill in the shadows but also provide some direction to the light. I carefully positioned my flash head to bounce its light off a pillar behind me to camera left. Nikon D700, 70-200mm, f/2.8, $^1/_{80}$ second, ISO 3200.

Be sure to consider the color of the surface you want to bounce the flash off of because the bounce surface's color will be transmitted back to the subject. If you bounce your light off of a red wall, the light on your subject will have a red cast. While this might be a cool effect, it is generally best to bounce off of a white or neutral surface or adjust your camera's white balance to compensate.

The spread of light from bounce flash can be controlled and shaped by using a flag or snoot to block the light from going where it is not wanted.

Off-Camera Flash. As we've shown in other examples, harsh, direct flash is generally not very flattering. It lacks the depth, dimension, and drama that directional light gives. We've shown that you can create beautiful directional light by changing the angle of the flash head and bouncing the light. Another way to achieve directional light is to take your flash off of the camera.

Flash sync cord.

Obviously, the flash and camera will need to communicate about when to fire the flash. If your flash only allows you to work in manual mode, you will need a radio trigger like the PocketWizard Plus III. If you would like to continue to use your flash's TTL capability, there are three ways to maintain communication between your camera and flashes: cords, built-in wireless flash capabilities, and TTL radio triggers.

Sync Cords. A sync cord simply attaches to the hot shoe of the camera, and the flash slips into the hot shoe on the other end of the cord. It's a simple and secure connection.

Built-in Wireless Lighting. Nikon and Canon's wireless flash systems give you the flexibility of using multiple off-camera flashes in

Here you can see two different approaches to photographing a performer at a wedding. In the first image, we used off-camera direct flash coming from behind to rim light the singer. In the second shot, we used flash bounced off of the ceiling. The images have two totally different looks, but both are acceptable.

This photo, taken on a rooftop patio, was made by putting my flash on a sync cord and bouncing the flash off the ground at an angle away from the couple. It created dramatic uplighting that suited the mood of the photo. Nikon D3, 24–70mm lens, f/2.8, $^1/_{25}$ second, ISO 4000.

TTL mode wirelessly. With the Nikon system, for example, you can have three groups of multiple flashes firing. The power level of each group can be controlled independently, letting you have more creative control over your lighting.

With built-in wireless lighting, the master flash (commander) communicates with the remote flashes through a series of pre-flashes in the TTL mode. As in normal TTL mode, these pre-flashes are used to determine a correct exposure. They also relay information to the remotes about the channel, group, and how much light the flash is supposed to emit.

Setting up and using a wireless flash system is easy. You will have a controller flash on-camera that you can choose to have fire and add to the exposure, or you can set it up as a commander flash so that all it does is communicate with the remotes about how much flash output to give. (Consult the owner's manual for the specifics on how to set up your flash units.)

There are a few limitations to the Nikon wireless system and all Canon flashes made before the Canon 600 EX-RT. The remote flashes need to be within the line of sight of the master unit. You will want to make sure that the light sensor window for wireless remote flash is turned toward the master flash so that it can see the master flash's instructions. The range of effectiveness is limited to

30 feet in front of the master unit and 23 feet to each side. Because the units communicate via relatively weak pre-flashes, bright mid-day sunlight can occasionally interfere with the communication between the units.

Canon's 600 EX-RT Speedlite offers two-way radio communication for compatible cameras. This gives you reliable wireless flash without the line-of-sight limitations of previous models. If you have a flash that doesn't have two-way radio communication, you will want to use TTL radio triggers to take advantage of your flash's TTL technology and have the reliability of a radio trigger.

It is extremely important that you are using fresh, fully charged batteries when working with wireless flash. The instructions for how much power to emit are transmitted in the pre-flashes. If there is not enough power to send or receive the complete set of instructions in the pre-flash, you can experience some fairly erratic behavior from the remote flash. Not knowing exactly how much flash power to output, it may make a full-power exposure followed

■ INSTRUCTIONS FOR HOW MUCH POWER TO EMIT ARE TRANSMITTED IN THE PRE-FLASHES.

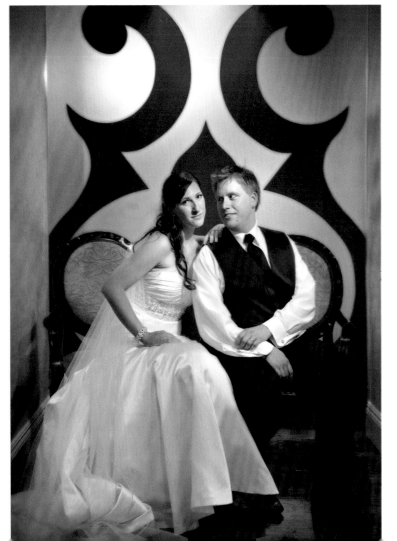

The Nikon wireless flash system allowed me to take my flash off of the camera to add directional light to this portrait of the bride and groom. I left the flash unmodified to match the hardness of the light falling onto the background from an over-head canned light. Nikon D700, 24–70mm, f/2.8, $^1/_{100}$ second, ISO 2500.

Photo of PocketWizard Mini TT1 and FlexTT5.

■ TTL RADIO TRIGGERS ALLOW FULL CONTROL OF MULTIPLE OFF-CAMERA FLASHES.

by an exposure that is several stops under. If you experience this, replace your batteries. Doing so will generally resolve erratic exposure issues.

TTL Radio Triggers. The flash's wireless built-in technology is very powerful, but it does have its limitations. The Nikon AWS requires that the speedlights have a line-of-sight connection and that the remotes be no farther than 30 feet from the master flash. There can also be some limits to the effectiveness of the system in bright midday sun.

In those cases when you need to place a flash out of the line of sight or farther than 30 feet away, it might be wise to invest in a set of TTL radio triggers. Also, anyone who needs wireless technology but might not be able to consistently maintain line of sight connection with the remote flash (like event and wedding photographers) should definitely consider TTL radio triggers. Like the AWS, TTL radio triggers allow full control of multiple off-camera flashes in TTL mode. They also allow you to work in high-speed sync. (Most standard manual radio triggers only allow you to work in manual flash mode at shutter speeds below the maximum sync speed.)

The two companies that are producing quality TTL radio triggers are PocketWizard and RadioPopper. While both systems offer TTL control of off-camera flashes, they each go about it differently. It should be noted that this technology is still relatively new and is constantly being improved upon.

PocketWizard Mini TT1 and FlexTT5. The PocketWizard line of TTL radio transmitters consists of the Mini TT1 transmitter, FlexTT5 transceiver, and AC3 ZoneController. There are specific units for Canon and Nikon flashes.

The PocketWizard system works by interpreting the CLS/TTL data being sent through the camera's hot shoe, converting it into its own proprietary code, and digitally transmits it in a radio signal to the receivers. This allows the PocketWizard system to add additional functions beyond those offered by the Nikon CLS. They have a range of up to 800 feet.

As a transmitter, the MiniTT1 or the FlexTT5 are mounted directly onto the hot shoe of your camera. One of the benefits of the PocketWizard system is that you do not need to have a flash attached as a master. This keeps the camera profile smaller and

lighter. You can adjust flash exposure compensation on the camera body.

If you need to adjust groups of flashes, you can attach a master flash (set to master), an SU-800, or the AC3 ZoneController to the hot shoe of the MiniTT1 or FlexTT5. All three of these options will allow you to control the flash output of the remotes in groups and change the flash modes for the remotes between i-TTL and manual.

Photo of RadioPopper PX.

As a remote, the flash is simply slipped into the hot shoe of the FlexTT5. Turn the flash to On (not Remote) and check to see that the mode is set to TTL. Make sure the correct channel and group are selected on both the transmitter and receiver.

The hot-shoe mounts and the switches on the side of the PocketWizard triggers make it very easy to set up and use the system.

When using the PocketWizard, it is important to first turn on the flash, then the PocketWizard trigger, then the camera. Also, as mentioned above, fresh batteries are an essential part of all TTL wireless systems.

RADIOPOPPER TRANSMITTERS. The RadioPopper system works a little differently than the PocketWizard system. Instead of intercepting and sending its own proprietary code, the RadioPopper transmitter senses the flash's pre-flash commands and sends them via radio waves to the receiver. The receiver then decodes the radio

Here, the flash was hidden in the golf cart and pointed at the ceiling. Nikon D3, 24–70mm, f/2.8, $^1/_{160}$ second, ISO 1250.

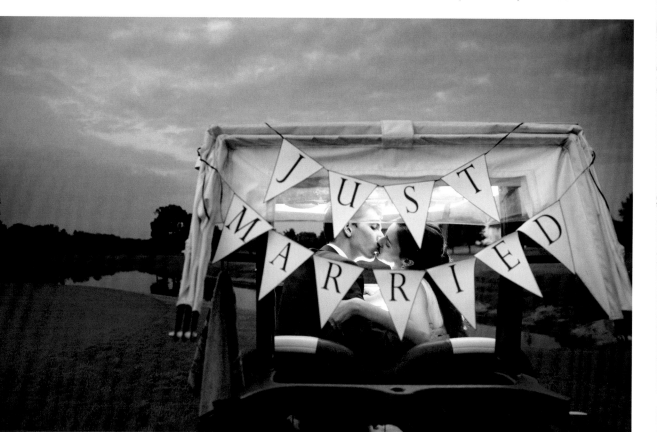

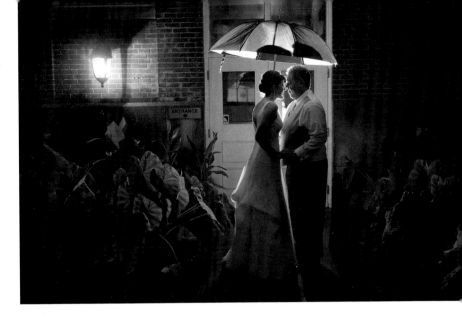

The flash was positioned right behind the couple, pointing directly at them. Nikon D3, 24–70mm, f/2.8, $^1/_{60}$ second, ISO 1250.

message into a series of infrared pulses that the remote speedlight is able to see as if they had been sent directly from the master flash.

The RadioPopper PX system is comprised of a transmitter and a receiver. The receiver sits on top of the flash head. You can either Velcro or attach it with an elastic band to the flash. The receiver has a special mount that places the unit directly in front of the flash's infrared sensor. It is important to make sure that the transmitter is mounted correctly in front of the sensor so that it can properly read the infrared pulses that the receiver transmits. The range of the RadioPopper unit is 1500 feet.

The RadioPopper system requires you to use a master flash unit. (For those cameras with a built-in flash, the RadioPopper system has an attachment that allows you to use the RadioPopper with the built-in flash as a master.) The nice thing about the RadioPopper units is that even with the units on the master flash, you can continue to trigger remote flashes with built-in wireless control, even if the remote does not have a RadioPopper trigger attached to it. (Normal wireless limitations such as a line-of-sight connection still apply to the flash units without a RadioPopper attached.)

■ **THE RADIOPOPPER SYSTEM REQUIRES YOU TO USE A MASTER FLASH UNIT.**

To use the RadioPopper triggers, set up your flashes as you normally would for the wireless flash mode. All of your RadioPopper units need to be on the same channel, and you'll need to make sure you've selected the correct camera-brand mode. (RadioPopper units can work with both Nikon and Canon systems by changing a menu setting.) Check to see that your batteries are well powered and the receiver is properly mounted to the remote flash.

MULTIPLE HOT-SHOE FLASHES

The Nikon Advanced Wireless System (AWS) allows you to control multiple flashes in as many as three groups. (The Canon system also lets you control multiple flash units wirelessly, but we find that the Nikon system gives you a bit better precision in controlling each flash individually.) Using multiple flashes lets you better show your subject's shape and dimension. Multiple lights are also used to better expose different parts of a scene, provide visual interest, or even completely change the mood of an image.

It is always a good idea to think of how each flash affects the scene separately. You might want one flash to overexpose the background. You might want one flash to act as a rim light. You might want one flash to provide just a touch of fill light. By understanding exactly what you want, you can easily control and set the different flash units to achieve your goal.

■ IT IS A GOOD IDEA TO THINK OF HOW EACH FLASH AFFECTS THE SCENE SEPARATELY.

Here, the flash was positioned outside the closed window of the limo and pointed at the couple. Nikon D700, 24–70mm, f/2.8, $^1/_{60}$ second, ISO 800. We would not have been able to create these three wedding photos without some form of radio trigger. In each case, the flash was placed in a location beyond the line of sight of the main flash on the camera.

For this late-night outdoor portrait of Matt, we used three Canon 580EX II flashes. The flashes were divided into two groups—group A for the main light and group B for the rim lights. The rim lights were powered down one stop from the main light. After I got the shot I envisioned (top-left image), I moved around in our lighting setup (see the pull-back shot on the right) and took a second photograph (top-right image). The rim lights became a fill and backlight. I like how the backlight caused lens flare and a bit of added colorful interest to the photo. Flashes triggered by RadioPoppers. Canon 7D, 50mm, f/2.8, $^1/_{30}$ second, ISO 800.

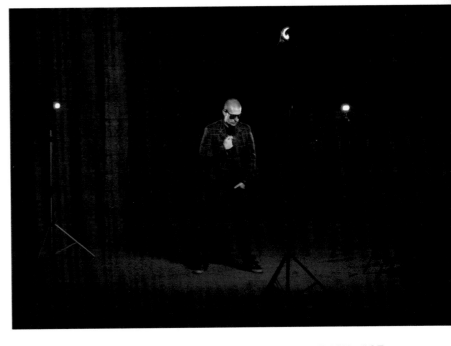

7. Modifying Flash

REASONS FOR MODIFYING FLASH

To become better photographers, we should develop an understanding of how to see the light, create the light, and shape the light we use in our photographs. There are two main reasons to modify the light from your flash:

- To diffuse the light by increasing the relative size of the light.
- To control, direct, or restrict the spread of light from the flash.

As we discussed earlier, the larger your light source is in relation to your subject's size, the softer and less well defined your shadows will be. Soft light can give your photos a pleasing and natural look.

There will be times when you want to light only certain parts of your image. Some modifiers will direct the light to specific areas, and others will restrict the light from spilling onto parts of the scene.

There are many different modifiers available for you to purchase, and we will discuss several different types. We will also discuss a few modifiers that you can quickly and inexpensively make yourself.

DOME DIFFUSERS

Both Nikon and Canon flashes come with dome diffusers that attach directly to the flash head. These small rectangular plastic diffusers are easy to carry and are not too bulky on the flash heads. The purpose of the diffuser is to scatter the light in many different

AN IMPORTANT NOTE

When we talk about flash in this chapter, we are talking about any artificial light source that flashes to cause illumination, whether it be a small hot-shoe unit that sits on your camera or a studio strobe that you plug into an external battery or wall outlet. If there is a difference in the modifier used depending on the type of flash, it will be specifically mentioned. Most example images were made with hot-shoe flashes, as they are very portable and readily available.

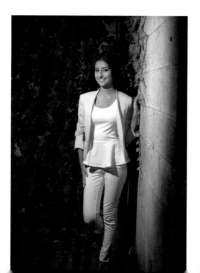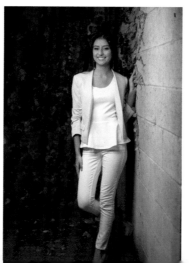

Modify your flash to change the quality of your light. Here, we show the difference between light from an unmodified flash (left image) and a flash in a softbox (right image).

Left—Direct flash. **Right**—
The effect of direct flash.

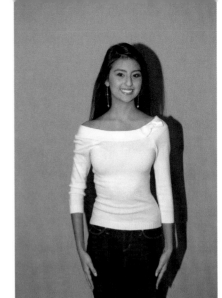

Left—Dome diffuser. **Right**—
Effect of factory-included
dome diffuser.

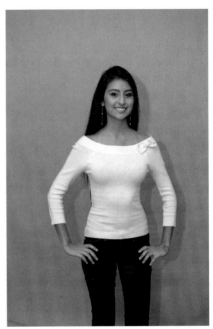

Left—Lightsphere by Gary
Fong. **Right**—Effect of Light-
sphere by Gary Fong.

directions so that the light is not as directional and the shadows are softer. Many photographers will tilt the head of the flash up to 45 degrees when using the diffusion dome. The idea is that you are able to bounce the flash off of the ceiling and walls while still directing some of the speedlight's light forward. While this does soften the shadows and give more pleasing light than direct un-modified flash, the light is still fairly flat and non-directional.

There are several other diffusers on the market, including the Gary Fong Lightsphere. While these modifiers do a fine job of diffusing the light (as you can see by the photos), the size of the modifier can be a bit cumbersome at times.

BOUNCE REFLECTORS/BOUNCE CARDS

Bounce reflectors and bounce cards are relatively inexpensive, easy to use, and practically indestructible. The whole purpose of a bounce card is to give you a surface to bounce the flash off of to spread the light around. The flash is pointed upward at a 90 degree

> ■ **A BOUNCE CARD GIVES YOU A SURFACE TO BOUNCE THE FLASH OFF OF.**

Left—Honl flag used as a bounce card. **Right**—Effect of Honl flag used as a bounce card.

Left—Rogue Flash Bender. **Right**—Effect of Rogue Flash Bender.

ENLARGING THE LIGHT SOURCE

Modifiers that increase the relative size of the light include:

For hot-shoe flashes
- Dome diffusers
- Bounce reflectors/ bounce cards

For hot-shoe flashes and strobes
- Umbrellas
- Softboxes
- Diffusion panels
- Beauty dishes
- Ring flashes

■ **UMBRELLAS ARE AN AFFORDABLE, EASY-TO-USE MODIFIER FOR YOUR FLASH.**

angle. The bounce reflector is attached to the flash so that the light from the flash is bounced forward onto the subject. Of course, this is just another way to soften the shadows and make the light look more natural.

There are a lot of inexpensive materials that work well as a bounce card. You can use anything from white foam core to thick index cards. Simply attach them with a sturdy rubber band and you have a bounce card for under a dollar. In extreme situations, if you don't want to use direct flash and have nothing to bounce off of, you can use your hand behind the flash to bounce light back onto the subject.

UMBRELLAS

Umbrellas are an affordable, easy-to-use modifier for your flash. There are two types of umbrellas—translucent umbrellas that you shoot the flash through and reflective umbrellas that bounce light back onto your subject. They come in all different sizes, from 30 to 72 inches. A larger umbrella will produce softer light and a greater dispersion of light.

Reflective umbrellas come with white, gold, or silver interiors. The white interior will produce the softest light, while the silver will reflect more light and give it more specularity. The gold lining will add warmth to the photo.

By firing your light through an umbrella, you are increasing the relative size of your flash and causing it to come from many angles. This makes the light softer. The same is true for a reflective umbrella. The difference is that the angle of diffusion is not as great with a reflective umbrella. The limitation of the umbrella is that it spreads the light quite a bit and you have limited control over where it goes. However, that is one reason why it is very good to use with large groups, when you want even light over a large area.

Convertible umbrellas let you have the best of both worlds—a reflective and a shoot-through umbrella in one. The black cover of the umbrella is removable, which allows the white interior to become a shoot-through umbrella.

Collapsible umbrellas are yet another option. One of the great benefits of working with hot-shoe flashes is having small, lightweight, portable lights that you can take on location. Collapsible umbrellas are a great addition to any portable studio kit. These

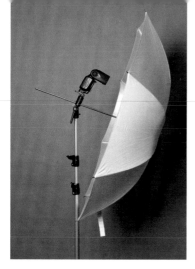

Left—Shoot-through umbrella. **Right**—Effect of shoot-through umbrella.

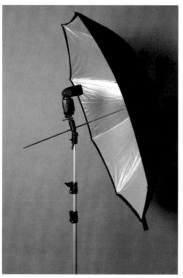

Left—Convertible umbrella. **Right**—Effect of convertible umbrella.

double-folding regular-sized umbrellas (usually about 45 inches) collapse to less than 15 inches long and easily fit into any case.

SOFTBOXES

Like umbrellas, softboxes increase the relative size of the light from a speedlight to create soft, beautiful lighting. However, softboxes give you much more control over where the light will go. As the name suggests, a softbox is a four- (or more) sided black nylon box with reflective material on the inside and a diffusion panel on the front. There is an opening in the back of the softbox to attach a flash or other light source.

Traditional studio softboxes are held open by metal rods that run through the corners of the box. These metal rods are attached to a speed ring in the back. The flash shoots through the speed

■ **SOFTBOXES INCREASE THE RELATIVE SIZE OF THE LIGHT FROM A SPEEDLIGHT.**

ring. The only problem with these types of softboxes is that they take a fair amount of time to set up and tear down. New folding softboxes, made with the on-location flash photographer in mind, are much easier to set up, tear down, and transport. They fold up like a traditional round reflector panel and fit into a compact carrying case. Westcott has an even easier softbox option that sets up just like a standard umbrella.

Softboxes come in many different sizes. There are some very small softboxes (8x8 inches) on the market that attach directly to your flash. But since you will still probably use the flash off of the

Top—Effect of Interfit Strobies 24x24-inch softbox with hot-shoe flash. **Bottom**—Interfit Strobies softbox (24x24 inches) with hot-shoe flash.

Top—Effect of Westcott 43-inch Apollo Orb with hot-shoe flash. **Bottom**—Westcott 43-inch Apollo Orb with hot-shoe flash.

Top—Effect of Westcott Apollo 28-inch softbox with hot-shoe flash. **Bottom**—Westcott Apollo 28-inch softbox with hot-shoe flash.

Top—Effect of Westcott 16x30-inch Apollo strip softbox without grid with hot-shoe flash. **Bottom**—Westcott 16x30-inch Apollo strip softbox without grid with hot-shoe flash.

Top—Effect of Westcott 16x30-inch Apollo strip softbox with grid with hot-shoe flash. **Bottom**—Westcott 16x30-inch Apollo strip softbox with grid with hot-shoe flash.

Top—Effect of Profoto RFi 3-foot Octa softbox with studio strobe **Bottom**—Profoto RFi 3-foot Octa softbox with studio strobe.

Far left—Effect of Profoto Softbox RFi 4x6-foot with studio strobe. **Left**—Profoto Softbox RFi 4x6-foot with studio strobe.

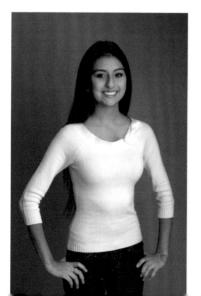

Photo of the interior of a Westcott Apollo 43-inch softbox.

camera, I recommend a larger softbox with a proper flash mount. The popular sizes for working with a single flash in a softbox are between 15x15 inches and 30x30 inches. You will also find softboxes called octoboxes; these have eight sides rather than four, giving it a more rounded shape.

The nice thing about the Westcott Apollo softboxes is that they are designed like umbrellas. It's very easy to set them up and attach them to light stands with standard umbrella mounts.

DIFFUSION PANELS/SCRIMS

Diffusion panels are large pieces of semi-transparent material stretched over frames. By placing the panel between your subject and your flash, you can diffuse the light and make shadows less defined.

The difference in the quality of light between a softbox and diffusion panel is that softboxes are capable of creating more even lighting across their front panel, especially when used with the internal baffles. There is oftentimes a hot spot that can be visible with a diffusion panel that baffles block or soften.

There are many different diffusion panel/scrim options available. Many collapsible reflector kits come with a diffuser disc. You can also purchase a frame system that provides proper support for a larger diffuser panel. If you want to go the do-it-yourself route, you'll appreciate the fact that a thick white bed sheet strung between two stands makes a large and inexpensive diffusion panel.

BEAUTY DISHES

A beauty dish is a parabolic reflector with a hole cut in it to mount the flash. A smaller second pan is mounted in front of the flash. Light from the flash bounces off the smaller pan and back into the larger main dish and is then directed toward the subject.

The nice thing about beauty dishes is that they are highly directional. Beauty dishes are a step between umbrellas and softboxes. The beauty dish diffuses the light, but it is a defined light that you can direct and feather like a softbox. The light from the beauty dish tends to not be as diffuse as light from a softbox.

The ideal distance to place your beauty dish from your subject is generally two times the diameter of the dish.

■ THE NICE THING ABOUT BEAUTY DISHES IS THAT THEY ARE HIGHLY DIRECTIONAL.

Top—Effect of Interfit Strobies beauty dish with hot-shoe flash. **Bottom**—Interfit Strobies beauty dish with hot-shoe flash.

Top—Effect of Profoto beauty dish with studio strobe. **Bottom**—Profoto beauty dish with studio strobe.

Top—Effect of Orbis ring flash. **Bottom**—Orbis ring flash.

RING FLASHES

The circular ring flash has gained a great deal of popularity in recent years. You will often see ring lights used in macro photography. It has also become very popular in fashion and portrait photography. Not only does the ring flash soften shadows, but the unique way that it renders light gives the model a shadowy halo, which is a common feature of fashion photography. Because it doesn't cast a set of directional shadows of its own, it is a popular way to provide fill light without introducing new shadows to an image.

The Orbis is an attachment that converts your regular flash into a ring flash. Simply attach the Orbis to your light, insert your lens through the Orbis, and you have a traditional ring flash. You can also use the Orbis off camera to provide a larger and softer light source than direct off-camera flash. You will need to control your flash by connecting it with a remote cord, the internal wireless

RESTRICTING THE LIGHT SPREAD

Modifiers that restrict the spread of the flash include:

For hot-shoe flashes:
• Built-in zoom control

For hot-shoe flashes and strobes:
• Gobos/flags
• Grids
• Snoots
• Ring flashes

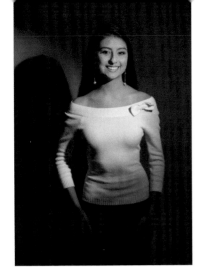

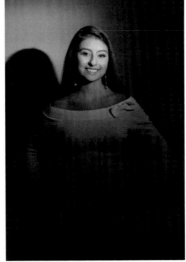

Top—Effect of Rogue Flash Bender as a snoot. **Bottom**—Rogue Flash Bender as a snoot.

Top—Effect of Honl grid. **Bottom**—Honl grid.

lighting system, or a radio system as we've described.

BUILT-IN ZOOM CONTROL

The built-in zoom function of the hot-shoe flash help maximize the effectiveness of your zoom lenses. It focuses the light to correspond to the angle of view of your lens. Choosing a focal length on your flash that is longer than your actual lens focal length will create a spot effect with the flash. For example, if your lens focal length is 24mm but your flash is zoomed to 200mm, the spread of light from the flash will be minimal—there will be a great deal of falloff, and most of the frame will not be illuminated.

SNOOTS

A snoot is a tube that attaches to the front of the flash. It restricts the spread of light coming from the flash head. It is a great tool to use to create a spotlight effect or to direct light in one specific location. The longer the snoot, the more restricted the spread of light will be.

Snoots can be made of all different types of material. Commercially produced snoots for flashes tend to be made out of a durable, flexible nylon material. You can make your own snoot out of Cinefoil. Because the material is flexible, there tends to be a natural unevenness to the edge of the light. If you are looking for a more precise edge, you will want to use a grid.

■ YOU CAN MAKE YOUR OWN SNOOT OUT OF CINEFOIL.

GRIDS

Like a snoot, a grid reduces the spread of light. However, it does so in a much more controlled, precise manner. Grids, which look like honeycombs, have a distinct and uniform lighting pattern. The

smaller the grid openings, the tighter the spread of light will be. Grids are extremely useful as hair lights, as they carefully direct the light onto the subject's hair, rather than allowing it to spill into other areas of the frame.

GOBOS AND FLAGS

Gobo is short for "go between." Anything that goes between the subject and the light can be called a gobo. Gobos are great for casting shadows and creating patterns of light and shadow.

Flags are specifically used to control the spread of your light. There may be times when you want to block the flash from falling on your background when you are trying to light your subject.

Flags are also useful when working with bounce flash. By flagging your flash, you block frontal lighting from the flash head. This means that you'll have more directional light when you bounce it with a flag. It is also useful on a crowded dance floor when you are trying to bounce light from behind you. It helps prevent you from directly firing your speedlight in the face of someone behind you.

GELS

Gels are thin, colored sheets of acetate that are placed over the flash head to change the color of the light. They come in all different colors and in varying degrees of color intensity.

There are two main reasons to gel your light—to correct white balance/color temperature and for creative effect.

Several companies, such as Honl, have a Velcro strap that attaches around the flash head and lets you attach oversized corrective and creative gels.

Many photographers buy large sheets of filter material and cut their own gels to fit their flashes. The gels are attached to the flash with gaffer's tape. This is the most economical way to quickly and easily gel your flash.

Corrective Gels. As mentioned earlier, mixing light sources with different color temperatures can lead to ugly photographs. The most common example of mixed lighting is when you have canned tungsten (warm/yellow/2800K) ceiling lights and flash. The ceiling lights create harsh shadows in the eye sockets. When you add light from an unmodified flash (cool/blue/5500K), the shadowed areas that are illuminated with flash will take on a blue

Top—Original image. **Center**—Here, we see the effect of flagging the background light to prevent light from spilling onto the subject. **Bottom**—The Honl flag.

Corrective gels.

Photo without gel.

With ¹/₂ CTO gel.

Colored gels.

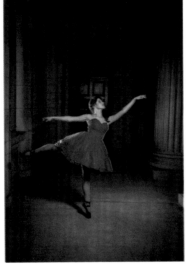

Without background light.

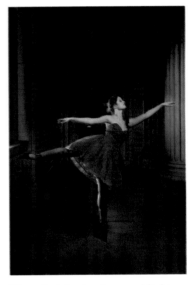

We gelled the background light red for a splash of color.

cast. It is almost impossible to correct for the different color temperatures. The way to handle a mixed-lighting situation is to gel your flash to match the ambient light.

Creative Gels. Gels come in a rainbow of colors, and using them properly can add a fair amount of drama or ambiance to a scene. You can change a very drab, boring, or neutral-colored room into something extraordinary by simply gelling your background light.

Part Four

PROBLEM-SOLVING ON LOCATION

In this part of the book, we'll look at sample sessions and show you why we choose the type of lighting that we do. We'll also compare different lighting solutions. Let's get started.

HARSH NOON SUN AND BRIGHT BACKGROUND

Bright midday sun is not the easiest light to work with. To make matters worse, we chose an unforgiving lighting location—a fountain in an open pavilion.

Our first step was to turn Laura's back to the sun. We knew the sun was too bright and would cause her to squint. Because the sun was so high in the sky, we knew we would have to watch out for "raccoon eyes."

IMAGE 4-1 is an available light photograph. When we exposed correctly for Laura's face, the highlights on her hair and hands were overexposed. Because the fountain was also overexposed and white, we lost all definition in her

Image 4-1. (below) Nikon D3, 70–200mm, f/4.5, $^1/_{320}$ second, ISO 200. Image 4-2. (top right) Nikon D3, 70–200mm, f/4.5, $^1/_{1250}$ second, ISO 200. Image 4-3. (bottom right) Pull-back shot.

Image 4-4. (above) Nikon D3, 70–200mm, f/16, $^{1}/_{250}$ second, ISO 200.

Image 4-5. (right) Pull-back shot showing setup.

hair. This meant we had to add light to produce a good photo.

In **IMAGE 4-2 AND IMAGE 4-3,** we added light from a silver reflector. The lighting was beautiful, but for our poor model, it was like staring into the sun.

We switched over to using a hot-shoe flash to make it easier on our model (**IMAGE 4-4**). (If I had brought my studio strobe with me, I would have preferred using it, as it is more powerful.) As we showed at the beginning of the book, when you switch over to high-speed sync, you lose 2 to 3 stops of effective power from your flash. Because I was working in bright sunlight and had a hard time matching the sun's exposure, even at full power, I chose to work at the maximum sync speed, not high-speed sync. This meant I would be shooting at $^{1}/_{250}$ second and f/16 at ISO 200.

The nice thing about using a reflector is that it creates a constant light source. This means I can use larger apertures and faster shutter speeds. Because I was using my flash at full power, I also had to be careful not to shoot too rapidly and give the flash time to fully recycle before taking my next photo.

HARD SUNLIGHT, DARK BACKGROUND

For this colorful photo, we positioned Neeta with the sun behind her, so it would act as a hair light. I knew that we would be adding more light to the photograph, so my first step was to find the settings that exposed the background the way I wanted. **IMAGE 4-6** shows you the ambient light settings. Next, we used a white reflector to add light to her face (**IMAGE 4-7**). While it was an improvement, I wasn't happy with the direction of the light we got with the reflector.

In **IMAGE 4-8,** we switched to the Profoto Acute B2 in a 3-foot Profoto octobox. I like the light illuminating her face better here.

Image 4-6. (top right) Nikon D3, 70–200mm, f/5.6, $^{1}/_{250}$ second, ISO 200. **Image 4-7.** (bottom right) Nikon D3, 70–200mm, f/5.6, $^{1}/_{250}$ second, ISO 200. **Image 4-8.** (left) Nikon D3, 70–200mm, f/5.6, $^{1}/_{250}$ second, ISO 200.

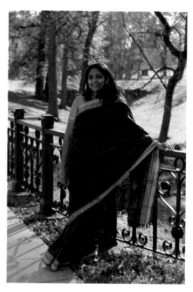

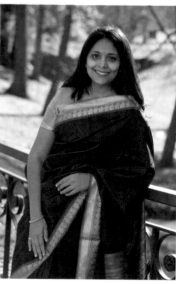

Image 4-9. (above) Nikon D3, 70–200mm, f/8, $^1/_{250}$ second, ISO 100.

Image 4-10. (right) Nikon D3, 70–200mm, f/8, $^1/_{250}$ second, ISO 100.

Image 4-11. Pull-back photo.

We found an awesome field of tall grass for the final photos of this session (IMAGE 4-10). I loved the texture of the grass being backlit by the sun. Once again, we used the sun as a hair light. I set my camera to properly expose for the sunlight on Neeta's hair and shoulders. IMAGE 4-9 shows the available light. We metered the flash to match the sunlight and created a beautiful portrait. IMAGE 4-11 shows the position of the flash.

SENIOR SESSION: AVAILABLE LIGHT, REFLECTORS, AND FLASH

In the mid-west, high-school senior portrait sessions usually include several outfit changes and different locations. This means that we will use many different lighting techniques to get the best photos from the session.

In **IMAGE 4-12 AND IMAGE 4-13,** you can see the effect of adding light to the image. I chose to use a reflector for two reasons: First, I wanted to control the exposure of the background. I felt it was too overexposed without the reflector. By adding light onto her face, I effectively made the background darker. The second reason why I used the reflector is that I wanted better catchlights in her eyes, which made her eyes sparkle.

After Alison changed outfits, we found a new location. We were fortunate enough to find a bit

Image 4-12. (left) With reflector. Nikon D3, 70–200mm, f/2.8, $^1/_{1600}$ second, ISO 400. **Image 4-13.** (above) Without reflector. Nikon D3, 70–200mm, f/2.8, $^1/_{500}$ second, ISO 400.

Image 4-14. (left) Final image. With reflected light. Nikon D3, 70–200mm, f/2.8, $^1/_{500}$ second, ISO 400.

Image 4-15. (right) Without reflected light. Nikon D3, 70–200mm, f/2.8, $^1/_{500}$ second, ISO 400.

Image 4-16. (left) Without flash. Nikon D3, 70–200mm, f/2.8, $^1/_{250}$ second, ISO 400.

Image 4-17. (right) With flash. Nikon D3, 70–200mm, f/4, $^1/_{250}$ second, ISO 400.

of sunlight reflecting off a nearby building (IMAGE 4-14). It created a natural spotlight on Allison. In IMAGE 4-15, you can see what the available light was like without the reflected sunlight. The light is softer, has a lot less direction, and isn't nearly as dramatic. This photo also lacks the great catchlights in the eyes.

We loved the interesting walls of the covered walkway in IMAGE 4-16, but unfortunately the light was not very interesting. To fix this, we added light from a hot-shoe flash in a softbox (IMAGE 4-17). We added flash because there wasn't any sunlight in a position where we could properly reflect it.

Image 4-18. (left) Without flash. Nikon D3, 70–200mm, f/4, $^1\!/_{250}$ second, ISO 400. **Image 4-19.** (right) With flash. Nikon D3, 70–200mm, f/4, $^1\!/_{250}$ second, ISO 400.

By the end of the session, it was getting dark. We wanted to get some photos with the cherry blossoms which, at that time, were in shade. In **IMAGE 4-18,** we exposed for the background and the warm glow of the setting sun in Allison's hair. In **IMAGE 4-19**, we added light from a flash in a softbox from camera right.

We also used flash in a softbox for this last photo. While there was enough light to make a proper exposure, I felt that the quality of the light wasn't great and that Allison got "lost" in the photograph **(IMAGE 4-20)**. By adding a bit of flash, I was able to direct the viewer's attention to Allison and improve the quality of light **(IMAGE 4-21)**.

Image 4-20. (right) Without flash. D3, 70–200mm, f/4, $^1\!/_{250}$ second, ISO 400. **Image 4-21.** (facing page) With flash. D3, 70–200mm, f/4, $^1\!/_{250}$ second, ISO 400.

Image 4-23. Main light.

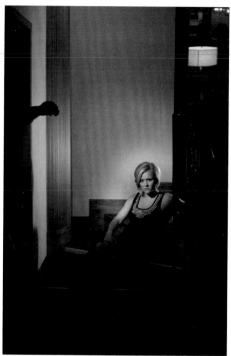

Image 4-24. Main and hair lights.

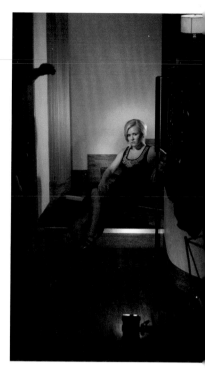

Image 4-25. Main, hair, and fill lights.

CLASSIC HOLLYWOOD LIGHTING, PART 1: VIDEO LIGHTS

Classic Hollywood-style lighting is inspired by the portraits of movie stars made during the 1940s. George Hurrell's work is an excellent example of this type of lighting. I like to create my classic Hollywood-style lighting with video lights. Here, we used three video lights to create the final photo.

You'll notice the different color temperatures in the lights. The main light was a halogen video light, the hair light was a daylight-balanced LED light, and the fill light on the floor was a tungsten-gelled LED light.

In the following images, you can see the progression of the lighting. **IMAGE 4-23** shows just the halogen video light used as a main light. While this is an acceptable photo, I wanted more separation from the background, so I added a hair light in **IMAGE 4-24**. I did not gel the hair light for the simple reason that I liked the way it looked. Next, I wanted to add a little fill light to her legs so I could see them better. For **IMAGE 4-25**, I gelled the LED light used as a fill light. I wanted to make sure that the color temperature of the fill light matched the main light so that they blended together properly.

In the final image, we flagged the hair light so that it didn't illuminate the wall behind it. In the process, I noticed that the light on the floor that was illuminating her legs was casting a shadow on the wall behind her. While I could have flagged or moved the fill light to get rid of it, I liked the shadow because it gave a bit of a mysterious feel to the photograph.

Image 4-22. (facing page) Final image. Nikon D3s, 50mm, f/2.5, $^1/_{100}$ second, ISO 1600.

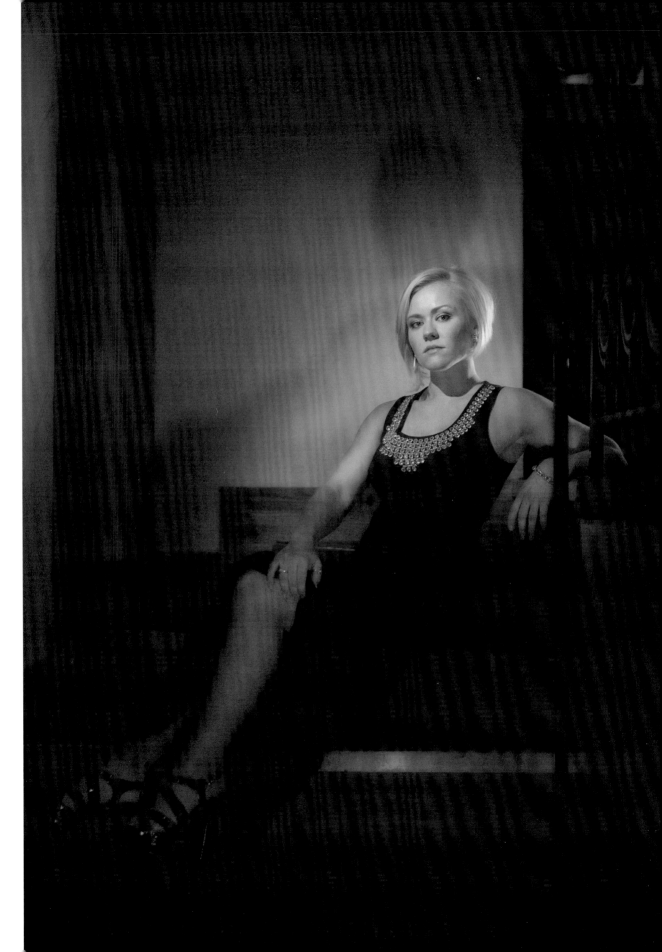

CLASSIC HOLLYWOOD, PART 2: VIDEO LIGHTS & ALTERNATIVE LIGHT SOURCES

You don't have to have expensive equipment to create great lighting for a portrait. For this image, we used an inexpensive LED light panel, a $20 LED strip light that I bought in the auto repair department, and a small $3 LED flashlight.

In **IMAGE 4-27,** you can see that there was little ambient light on Donny's face, which allowed me to add and control all the light to illuminate him.

We used the LED panel as a main light, the car light as a hair light to provide separation from the background, and the flashlight as a small spotlight for the martini glass. The only problem with using inexpensive light sources from three different manufacturers was that all three of my light sources had different color temperatures (**IMAGE 4-28**). To combat this problem, I converted the photo to black & white (**IMAGE 4-26**). I like the classic feel of the black & white photo.

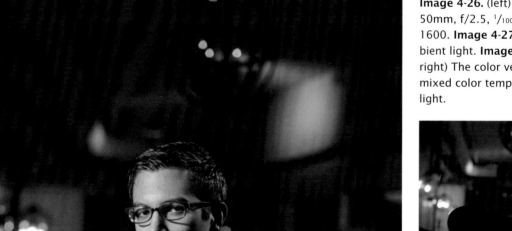

Image 4-26. (left) Nikon D3s, 50mm, f/2.5, $^1/_{100}$ second, ISO 1600. **Image 4-27.** (top right) Ambient light. **Image 4-28.** (bottom right) The color version shows the mixed color temperatures of the light.

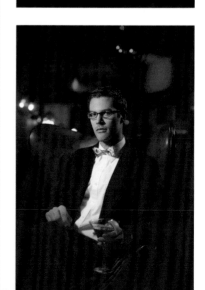

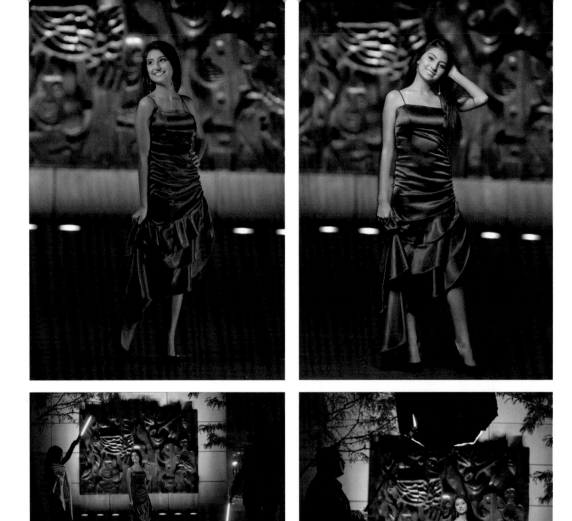

Image 4-29. (top) Nikon D3s, 70–200mm, f/2.8, ¹/₁₀₀ second, ISO 1600. **Image 4-30.** (bottom) Pull-back photo.

Image 4-31. (top) Nikon D3s, 70–200mm, f/2.8, ¹/₁₀₀ second, ISO 800. **Image 4-32.** (bottom) Pull-back photo.

LADY IN RED: LED LIGHT VERSUS FLASH

These photos of Tabitha show the difference between working with the Westcott Ice Light (IMAGE 4-29 AND IMAGE 4-30) and a hot-shoe flash in a Westscott Apollo Orb (IMAGE 4-31 AND IMAGE 4-32). The shoot was held at night. Working with constant light sources made it easy to see my subject and focus my camera. I needed two lights: one provided a pleasing lighting pattern on her face and one lit her legs. I positioned the lights on either side of her to create background separation.

The Westcott Apollo Orb is a much larger light source and has a greater spread of light. I needed only one light to fully illuminate my subject. As there was no modeling light, I struggled with my camera focusing on the lit wall behind her.

Both lighting solutions create beautiful results. It's a matter of personal choice as to which you choose to use.

THE WINE CELLAR: MULTIPLE FLASHES

When Jennifer told me we had access to a wine cellar, I was pretty excited. The room was filled with an incredible collection of fine wines, and I knew it would make a great location. The only problem was that the available light was less than ideal. The lighting consisted of a few small canned lights in the ceiling and accent lights in the shelving. I would have to light both my subject and the location.

The space in the room was fairly tight, which made using small hot-shoe flashes ideal. The PocketWizard Flex system came in handy because I could hide my flashes in the shelving to light the background.

I used three flashes. The main flash was set to the A group and pointed at Jennifer. I zoomed the flash head to 105mm to create a spotlight effect on her. The other two flashes were set to the B group so I could control them independently of the main flash. They were hidden in the shelving on both sides of Jennifer and pointed behind her.

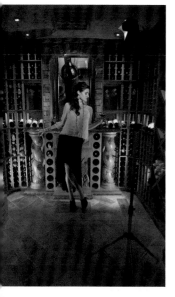

Image 4-33. (below) Nikon D3s, 24–70mm, f/3.5, $^1/_{50}$ second, ISO 1250. Image 4-34. (far left) Pull-back shot. Image 4-35. (left) Without flash.

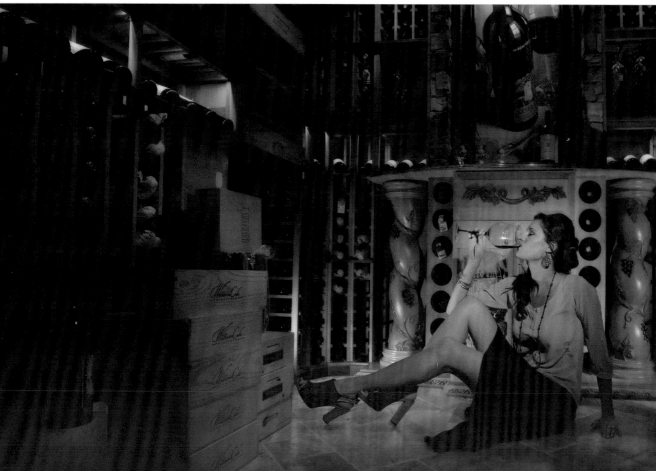

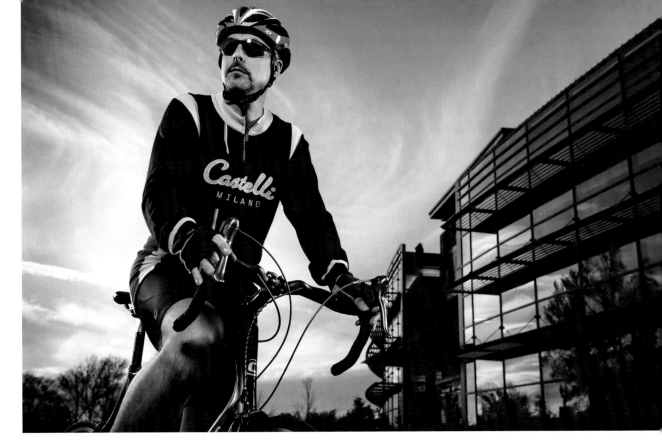

THE CYCLIST: MULTIPLE FLASHES

The only instructions we had for this photo were "make me look good." So when we took this photo of Ray, I knew that I wanted a dramatic sky and lighting.

My first step was to get a proper exposure for the sky. Next, I set up my lighting. While it took a moment to set up, the lighting was simple—but it created a dramatic, professional look.

We used Nikon SB-910 Speedlights in a Westcott Apollo softbox as the main light. We used two Westcott strip softboxes ("stripbanks") with grids as rim lights. The rim lights were set to one stop brighter than the main light. All flashes were triggered by the PocketWizard Flex system.

Image 4-36. (above) Finished photo. Nikon D3s, 24–70mm, f/4.5, $^1/_{250}$ second, ISO 200. **Image 4-37.** (below) No light. Exposure set for sky. **Image 4-38.** (bottom left) and **Image 4-39.** (bottom right) Pull-back photos.

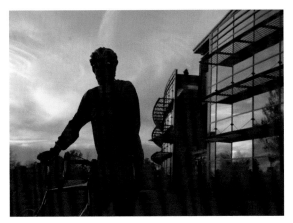

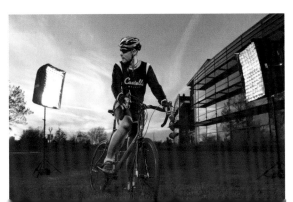

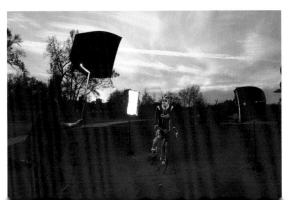

BALLERINA, PART 1: MULTIPLE FLASHES

Mandy is a talented, intelligent, and accomplished young lady with big dreams. When she arrived for her senior portrait session with a beautiful red dress and a pair of black pointe shoes, I decided to highlight her elegant form and give her a sense of strength and power. An old vacant church with large stone pillars proved the perfect backdrop to convey that sense of strength.

It was almost completely dark by the time we arrived at the location. The only available light came from a dim streetlight. I knew that I would have to use my speedlights to create some dramatic light for the photograph I had envisioned.

I used two Nikon SB-900 Speedlights, two PocketWizard FlexTT5s, a PocketWizard Mini-TT1 with the AC3 accessory, and a Lastolite 24-inch EZYBOX softbox. I like hot-shoe flashes because they are portable and allow me to work in i-TTL mode. The PocketWizard Flex system allows me to work with radio signals instead of line-of-sight technology, and I can put my flashes almost anywhere I want and I know they will fire.

One speedlight was used with the softbox to camera left. I used off-camera lighting to throw directional light onto my subject. This allows you to better see Mandy's shape and the texture in her dress. I opted to use a softbox because I wanted the shadows to be softer than the high-contrast, well-defined shadows you would get with direct off-camera flash. The speedlight was used in i-TTL mode on the A channel.

IMAGE 4-41 shows you the effect of using just the speedlight in a softbox. It's not bad, but I found that I wanted to separate my subject from the background so I could draw more attention to her and make it a more dramatic image.

In IMAGE 4-42, you can see the lighting setup and placement for the final image.

For the finished photo, I placed a speedlight on the steps directly behind my subject. I had the second flash on the B channel so that I could independently adjust its power output in comparison to my main light. Because the flash was pointed directly at my subject as a rim light, I dialed down the exposure value compensation to -2. Using the AC3 accessory on the MiniTT1 allowed me to quickly and easily adjust my flash power output with the quick flick of a dial.

It was very easy and quick to set up this photograph. Adding in the second flash truly made the image. The finished result is a striking portrait of an elegant and talented young woman.

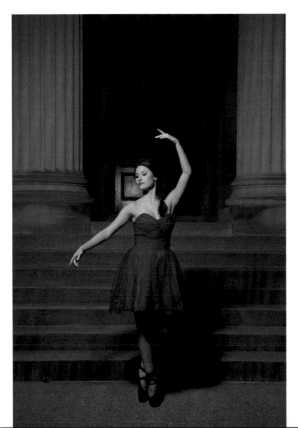

Image 4-40. (facing page) Nikon D3s, 24–70mm, f/2.8, $^1/_{80}$ second, ISO 500. Image 4-41. (left) One flash, no back light. Image 4-42. (below) Pull-back photo.

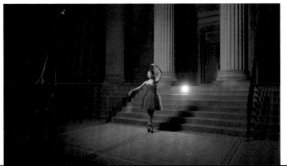

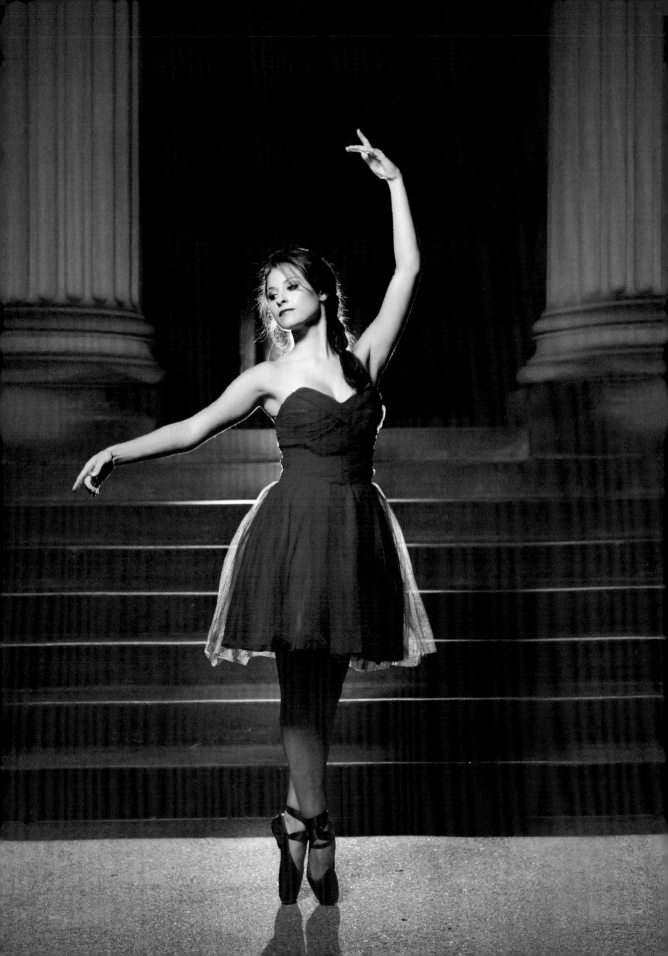

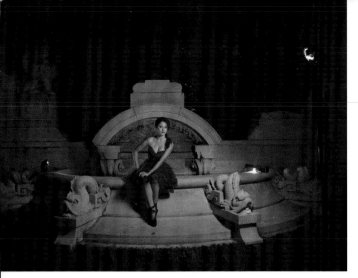

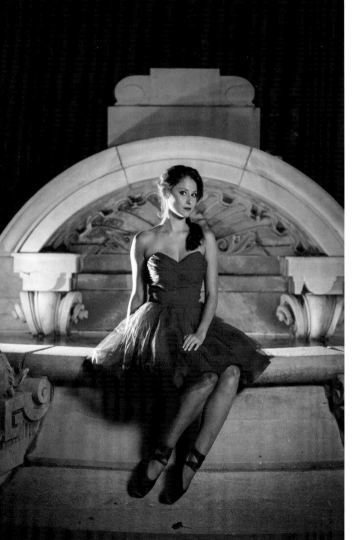

BALLERINA, PART 2: MULTIPLE FLASHES AND GELS

Since we were photographing at night and there was no light on the fountain, I thought it might be fun to play with some colored gels to light it up.

To camera right, we placed a hot-shoe flash with a red gel at the edge of the fountain pointing at the background. A second flash, this one gelled blue, was pointed at Mandy to give her a bit of a blue rim light. The main light was a hot-shoe flash in an Interfit 24x24-inch softbox. All flashes were triggered by the PocketWizard Flex system. (See **IMAGE 4-43 AND IMAGE 4-44**.)

In **IMAGE 4-45**, you can see what happened when I had all flashes set to equal power and unmodified. The blue-gelled flash was too bright, and the highlights on Mandy were overexposed. It's an interesting photo, but it wasn't what I had planned. We snooted the blue-gelled flash with a bit of black craft foam and powered it down so that the light hit only Mandy and was less bright than the other flashes.

Image 4-43. (facing page) Nikon D3s, 24–70mm, f/2.8, $^1/_{80}$ second, ISO 500.

Image 4-44. (top left) Pull-back photo.

Image 4-45. (bottom left) Unmodified blue-gelled flash.

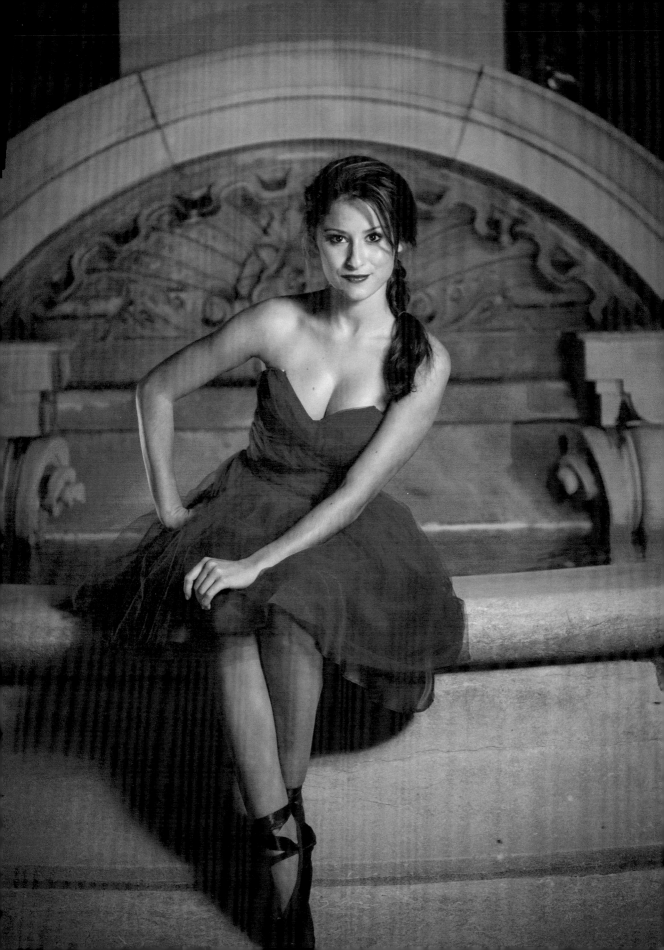

Image 4-46. Nikon D4, 24–70mm, f/2.8, $^1/_{60}$ second, ISO 1600.

Image 4-47. Nikon D4, 24–70mm, f/5.6, $^1/_{30}$ second, ISO 400.

THE BLUE ROOM, PART 1: WINDOW LIGHT VERSUS FLASH

Allison is properly exposed in both of these photos, but they have two very different looks. In IMAGE 4-46, she is lit entirely by window light coming through a window to camera left. Notice how the window behind her is blown out and you can't see any detail in the curtains.

For IMAGE 4-47, we used a Profoto AcuteB2 in a Profoto beauty dish to light the photograph. We set the exposure so that the ambient light was slightly underexposed so the flashlight would draw attention to Allison. Notice that you can see the curtains and the trees outside the window in this image.

THE BLUE ROOM, PART 2:
ONE VERSUS TWO FLASHES

With just the one light, Allison's pants blend into the black fireplace—IMAGE 4-45. To improve the photograph, I knew I had to add some light on her pants to separate her from the background.

The only problem was that I was very limited by the equipment I had with me. I had a studio strobe that I was using as a main light that I was triggering with a PocketWizard Plus II and a Nikon SB-900 as lighting tools. Somehow I had forgotten my reflectors, which I felt I needed in order to add the light, so I had to improvise.

Thankfully, the Nikon Speedlights have an SU-4 mode, which acts like a white light slave to trigger the flash. This means that whenever another flash fires, it will trigger the speedlight. This way, I could use the Profoto studio strobe as the main light and the speedlight as a fill light.

Image 4-48. Pull-back photo.

In IMAGE 4-48, you can see the lighting setup. I used an assistant as a light stand (to camera right) since I only had one of those also. I try to ensure I have the equipment I need to face any situation, but in this line of work, you sometimes get caught without the things you need. This is where thinking outside the box can save your shot. IMAGE 4-50 is the final result.

Image 4-49. (left) One light. Image 4-50. (right) Two lights. Nikon D4, 24–70mm, f/9, ¹/₈₀ second, ISO 400.

VENETIAN JEWELRY FASHION SHOOT: AVAILABLE LIGHT, REFLECTORS, & FLASH

We were hired to photograph a fashion shoot for a Venetian jewelry company that wanted to give its ad campaign a new, fresh feel. The idea was to create three different looks to prove that the jewelry could be worn casually, for business, or a night out. This meant that we not only had to change out the women's outfits, we also had to change the lighting to fit the look. We had six women to photograph, and we only had them for one hour each. We were working in a large mansion with a classic Italian feel. Our available lighting conditions ranged from bright sun, to window light, to open shade, to a ballroom with chandeliers. We supplemented the light with reflectors and hot-shoe flashes. We had to work quickly and efficiently to cover several looks in a short amount of time. Here is a sampling of the photos and an explanation of how we adjusted the lighting to get the look we wanted.

We started photographing at about 11:00AM. The sun was bright and high in the sky. To keep a fresh, casual feel to the photos, we stayed inside and worked with window light. For **IMAGE 4-51,** we used soft frontal window light. The warm glow in the background was created by the tungsten lights and matched the color of the jewelry perfectly. In **IMAGE 4-52,** you can see a pull-back view of the room and the effect of the light coming through the window.

For the second model, we moved to the front part of the building that was in open shade. The light was very flat and unexciting. For **IMAGE 4-53,** we opened the front doors (you can see the doors in the back of **IMAGE 4-52**) and had the model step back into the building to create some direction to the light on her face. In **IMAGE 4-54,** you can see a photo taken in front of the doors in open shade. It's not nearly as good as the previous image.

Image 4-51. (facing page) Nikon D3, 70–200mm, f/5.6, $^1/_{200}$ second, ISO 400. **Image 4-52.** (above) Pull-back photo.

Image 4-53. Nikon D3, 70–200mm, f/5.6, $^1/_{250}$ second, ISO 400.

Image 4-54. Nikon D3, 70–200mm, f/5.6, $^1/_{250}$ second, ISO 400.

Image 4-55. (above) Just rim light. Nikon D3, 70–200mm, f/9, $^1/_{250}$ second, ISO 200.

Image 4-56. (left) Main and rim light. Nikon D3, 70–200mm, f/9, $^1/_{250}$ second, ISO 200.

Image 4-57. (facing page) Reflector. Nikon D3, 70–200mm, f/8, $^1/_{400}$ second, ISO 800.

Since the art director wanted to use the front door as a background and we knew the available light wasn't cutting it, we were going to have to create the lighting. We had two goals in mind: to create a photo that looked like it was taken at night and also one that was taken during the day with a lot of color and pop. In **IMAGE 4-55 AND IM-AGE 4-56**, we underexposed the ambient light to make it look like nighttime and added a flash in a

softbox to light our model from camera left. To separate her from the background, we added a rim light pointing at her back from camera right.

For the sunny photo, **IMAGE 4-57,** we used a silver reflector to camera right to bounce sunlight back into the open shade. The reflector was almost 20 feet from our model because that was where the sun was. We feathered the light slightly so that the shadows were not too hard.

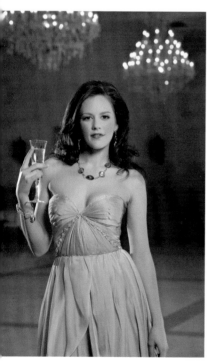

Image 4-58. (top) Just main light. Nikon D3, 70–200mm, f/6.3, $^1/_{100}$ second, ISO 400. **Image 4-59.** (bottom) Main and rim light. Nikon D3, 70–200mm, f/6.3, $^1/_{250}$ second, ISO 400.

Image 4-60. (top) Bad reflector lighting. Nikon D3, 70–200mm, f/6.3, $^1/_{400}$ second, ISO 200. **Image 4-61.** (bottom) Good reflector lighting. Nikon D3, 70–200mm, f/6.3, $^1/_{250}$ second, ISO 200.

Image 4-62. (top) Bad direct sun. Nikon D3, 70–200mm, f/6.3, $^1/_{2500}$ second, ISO 200. **Image 4-63.** (bottom) Good direct sun. Nikon D3, 70–200mm, f/6.3, $^1/_{2500}$ second, ISO 200.

Image 4-64. Flash in softbox. Nikon D3, 70–200mm, f/6.3, ¹/₂₅₀ second, ISO 200.

Back in the ballroom, we tried to create a photo that appeared to be taken at a gala event. We used a hot-shoe flash in a softbox to camera right. I felt that the background was too bright in **IMAGE 4-58.** I increased the shutter speed to reduce the ambient light in **IMAGE 4-59.** A rim light was added from camera left to produce a few highlights on the champagne glass.

For **IMAGES 4-60 AND 4-61,** we headed outdoors. The sun was still very bright, so we found a place in the shade and decided to use a reflector to add in more light under the hat. In **IMAGE 4-60,** the lighting was poorly done. The light coming from the reflector to camera left was too direct and hard and caused unflattering shadows on her nose and hat. In **IMAGE 4-61,** we moved the reflector to camera right and feathered the light to create a better result.

When you look at **IMAGE 4-62 AND IMAGE 4-63,** you can see how important it is to properly position your model in the sunlight. In the first photo, the sun was casting unflattering shadows on her face. By turning her face into the light, we were able to create a better lighting pattern on her face in the second photo.

The sun was starting to set quickly by the time we took a group photo **(IMAGE 4-64).** We metered for the background and added flash in a softbox

from camera left to give the scene a warm, summery feel.

IMAGE 4-66 was photographed with one speedlight in a softbox to camera left. What I like about this photo is the sky reflecting in the glass, so I chose camera settings to make sure it appeared in the final photo. **IMAGE 4-65** shows what the photo looked like without flash.

By the time we shot **IMAGE 4-67,** it was almost completely dark outside. For this photo, we used a softbox to camera right and a direct flash side lighting the bushes to show off their texture and shape.

Image 4-65. (left) No flash. Nikon D3, 70–200mm, f/5.6, $^1/_{250}$ second, ISO 200. **Image 4-66.** (facing page) Flash in softbox. Nikon D3, 70–200mm, f/5.6, $^1/_{250}$ second, ISO 200.

Image 4-67. (bottom left) No flash. Nikon D3, 70–200mm, f/5.6, $^1/_{30}$ second, ISO 1600. **Image 4-68.** (bottom right) Flash in softbox. Nikon D3, 70–200mm, f/5.6, $^1/_{30}$ second, ISO 1000.

Image 4-69. No flash. Nikon D3, 70–200mm, f/5.6, $^1/_{30}$ second, ISO 3200.

Image 4-70. Direct flash. Nikon D3, 70–200mm, f/8, $^1/_{30}$ second, ISO 800.

For the last photos, the art director was looking for something a bit edgier. We had shot an available light image earlier (IMAGE 4-69), but it just wasn't what the art director wanted. When we shot it again, we decided to use direct off-camera flash to create some hard shadows to give the photo an edgy feel. In IMAGE 4-70, we used only one light to camera right. We added a hair light to camera left in IMAGE 4-71, but I found it to be too bright. We powered down the hair light and moved the subject in front of part of the garden being lit by floodlights to get the final image (IMAGE 4-72).

Image 4-71. (left) Direct flash with rim light. Nikon D3, 70–200mm, f/8, $^1/_{30}$ second, ISO 800.

Image 4-72. (facing page) Direct flash with rim light powered down. Nikon D3, 70–200mm, f/8, $^1/_{30}$ second, ISO 800.

THE COFFEE SHOP: WINDOW LIGHT

While taking photos of Chad, I placed him between two windows (**IMAGE 4-75**) and was able to get two very different photographs. The sun was streaming through the photo on the right-hand side of the photo. In the first photo (**IMAGE 4-73**), I had him move out of the direct sunlight and turn toward the diffused light of the left-hand side window. Notice how soft the shadows were in this photo. In the second photo (**IMAGE 4-74**), I had him lean back in the chair and face the sun coming in through the window. Notice how hard the shadows were and how different the photo feels from the other one.

Image 4-73. (top) Nikon D3s, 24–70mm, f/2.8, $^1/_{250}$ second, ISO 640.

Image 4-74. (facing page) Nikon D3s, 24–70mm, f/2.8, $^1/_{800}$ second, ISO 640.

Image 4-75. (bottom) Pull-back photo.

BRIDAL PORTRAIT IN THE SHADE: FILL FLASH

We wanted to include a bit of the fall color of the background in this bridal portrait. But as you can see in IMAGE 4-76, the shade was a bit too dark to get a proper exposure on the couple and still properly expose the trees. To improve the light-ing, we added a bit of fill flash in IMAGE 4-78. IMAGE 4-77 shows what it looked like when we used the flash as the main source of illumination instead of fill light. Not only is it ugly direct on-camera flash, but also I find the flash to be too apparent in the photograph. The fill flash looks much more natural.

Image 4-78. Fill flash. Nikon D3s, 24–70mm, f/4, $^1/_{250}$ second, ISO 400.

Image 4-76. (top) No flash. Nikon D3s, 24–70mm, f/4, $^1/_{250}$ second, ISO 400. **Image 4-77.** (bottom) Direct flash. Nikon D3s, 24–70mm, f/4, $^1/_{250}$ second, ISO 400.

WEDDING PARTY PHOTOS: FLASH

While we often like to use natural light to photograph our wedding parties, the location the bride and groom chooses doesn't always work well for natural light. In those cases, off-camera flash comes in handy. Here are three examples of how we lit a wedding party with off-camera flash.

In **IMAGE 4-79,** the bride and groom wanted photos in front of the arch. At that time of the day, the place they were standing was in the shadow of a building. If I had exposed for the wedding party, the arch and sky would have been overexposed, which would have negated the whole point of the photograph. Instead, I exposed for the sky and added some off-camera flash to camera right **(IMAGE 4-80).**

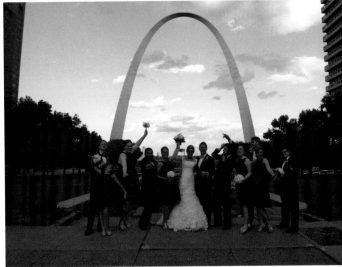

Image 4-79. (above) No flash. Nikon D3s, 24–70mm, f/6.3, $^1/_{250}$ second, ISO 400. **Image 4-80.** (top) Flash. Nikon D3s, 24–70mm, f/6.3, $^1/_{250}$ second, ISO 400.

While we had some big windows to work with in this hotel lobby **(IMAGE 4-81),** if I had used the window light, I would have struggled with a cluttered background full of guests checking into the hotel. Instead, I turned the subjects' backs to the window and added an off-camera flash to camera right.

We handled the bright sunlight by turning our wedding party's backs to the sun and using it as a hair light **(IMAGE 4-82),** but if we were going to properly expose for the background and the people, we had to add more light. We used direct flash to get all the power out of our flash that we could to match the brightness of the sun.

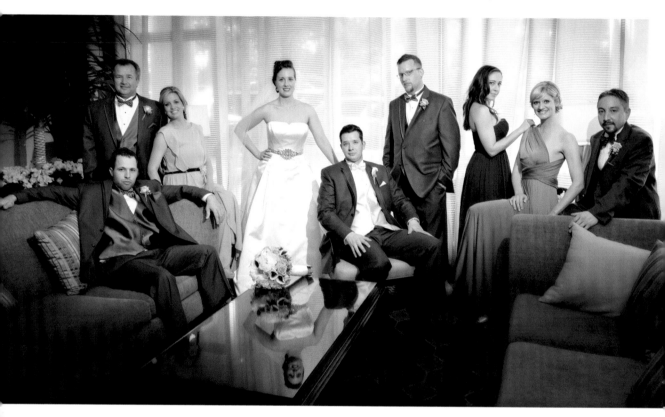

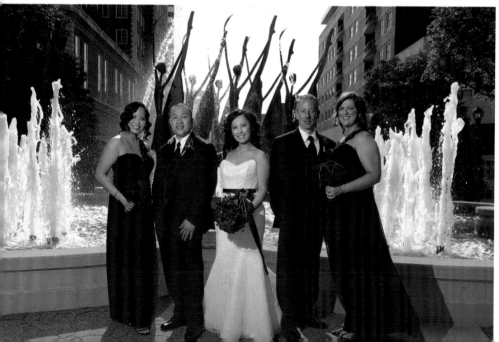

Image 4-81. (above) Flash. Nikon D3s, 24–70mm, f/4.5, $^1/_{250}$ second, ISO 1000.

Image 4-82. (left) Flash. Nikon D3s, 24–70mm, f/8, $^1/_{250}$ second, ISO 100.

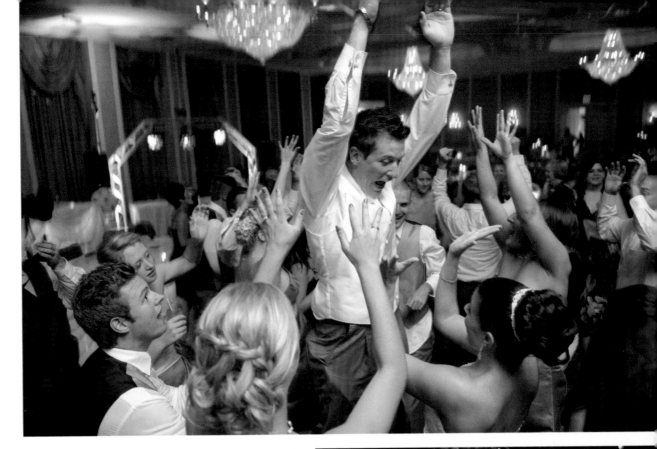

Image 4-83. Nikon D3, 24–70mm, f/2.8, ¹/₆₀ second, ISO 1600.

WEDDING RECEPTION LIGHTING: FLASH

We light a lot of our wedding reception photos by bouncing flash off of the ceiling of the reception venue. This is how we lit **IMAGE 4-83.** We liked the relatively natural look we got by bouncing our flash off the ceiling from camera right.

Sometimes the angle we photograph from requires us to do something other than bounce flash off of the ceiling. In **IMAGE 4-84**, I wanted to get an interesting angle of the "pie cutting." I was faced with two problems: there was nothing to bounce the light off of since the ceiling was 50 feet above me in a very dark room, and it would take some great precision to be able to light the couple without overexposing the pies. I chose to use direct off-camera flash held by an assistant and pointed at the couple. This way, I could

Image 4-84. Nikon D3, 24–70mm, f/2.8, ¹/₁₅ second, ISO 800.

move around the table to get the right position, and I knew that my light would be consistent.

For some wedding reception photos we use a combination of bounced flash and direct flash

as a rim light. In **IMAGES 4-85 AND 4-86,** we had a flash set up on a stand behind the couple (you can see a bit of the flash flare in **IMAGE 4-85**), and then we bounced on-camera flash to illuminate the couple. This allowed us to have diffused, flattering light on the subjects' faces and provide a rim light to separate them from the background, which resulted in more dramatic lighting.

Image 4-85. (left) Nikon D3, 24–70mm, f/2.8, $^1/_{60}$ second, ISO 1600.

Image 4-86. (below) Nikon D3, 24–70mm, f/2.8, $^1/_{60}$ second, ISO 800.

Conclusion

We hope that this book has provided you with the tools and confidence you need to create a great photograph, no matter what lighting situation you may find yourself working in. Hopefully you have noticed that there are many different solutions to any lighting challenge. The more you experiment, practice, and explore your lighting options, the easier it will become to create images. Don't be afraid to try something new.

RESOURCES

EQUIPMENT

Nikon USA—www.nikonusa.com

Canon USA—www.usa.canon.com

Profoto—www.profoto.com

PocketWizard—www.pocketwizard.com

Sekonic—www.sekonic.com

Mac Group—www.macgroupus.com

Westcott—www.fjwestcott.com

Schiller's Camera and Video—www.schillers.com

RadioPoppers—www.radiopoppers.com

Honl—www.honlphoto.com

Strobies—www.interfitphotographic.com

Orbis—www.orbisflash.com

Rogue—www.expoimaging.com

EDUCATION

After Dark Education—www.afterdarkedu.com

Jerry Ghionis—www.jerryghionis.com

Tony Corbell—www.corbellproductions.com

David Hobby—www.strobist.blogspot.com

Index

A

Ambient light, 38–42, 47–74, 124, 141–48
Aperture, 29–30, 33, 41–42
Assistants, 139

B

Background lights, 82, 119, 132, 136, 139, 141
Backgrounds, 26, 34, 119, 122–23, 124, 128, 130, 131, 132, 139, 142, 144
dark, 122–23
separation, 26, 128, 139
Backlighting, 19, 52, 54
Batteries, 75, 78, 79, 82, 91–92
Beauty dishes, 93, 115–16, 138

C

Catchlights, 14, 51, 56, 96, 125
Characteristics of light, 11–28, 47, 49, 64, 66, 82, 88, 128, 130
color temperature, 13, 26–28, 64, 82, 88, 128, 130
contrast, 16
direction, 11, 18–19, 47
hard light, 14–15, 47, 49, 87
intensity, 11, 14–15, 47
soft light, 15, 47, 49
Cloudy skies, 11, 16, 56, 59, 74, 87
Color casts, 51, 58–59, 62, 79
Color temperature, 13, 26–28, 64, 82, 88, 128, 130; see also White balance

Continuous light sources, 9, 26, 27, 50, 64, 29, 76–85, 128, 130, 131

D

Deep shade, 57–58
Depth of field, 30, 33, 37, 42

E

Exposure, 29–44, 53, 54, 91
aperture, 29–30, 33
equivalent, 33
evaluating, 33
flash, 38–42
ISO, 32–33, 42
overexposure, 29, 33, 42, 54
metering, 33, 53–54, 91
shutter speed, 30–32
underexposure, 29, 36, 42, 53

F

Falloff, 15, 37, 65, 117
Fill lights, 26, 69, 96–97, 128, 138, 139, 152
Flags, 16, 68, 72–74, 118, 128
Flash, 9, 39–41, 42–44, 75–119, 122–23, 125, 126, 132, 133, 134–36, 138, 139, 145, 147, 152, 155–56
bounced, 97–100, 155–56
fill, 96–97, 138, 139, 152
hot-shoe, 75, 76, 121, 125, 126, 132, 133, 134–36, 139, 145, 147
modeling lights, 89
monolights, 9

(Flash, cont'd)
multiple units, 106–107, 132, 133, 134–36
ring, 116–17
studio strobes, 75, 88–94, 138, 139
sync cords, 93, 100
sync speeds, 39–41, 42–44, 121
triggering, 93–95, 100–105
zoom controls, 116, 117
Fluorescent light, 27, 50, 64
Frontal lighting, 19, 51–52

G

Gels, 88–89, 118–19, 128, 136
Gobos, 72–74
Grids, 117–18, 133
Group portraits, 37, 145–47, 154

H

Hair lights, 26, 122, 128, 130, 148
Halogen lights, 76, 81, 84
Highlights, 16, 33
Histograms, 33, 34, 35–36
Hollywood lighting, 128, 130
Hurrell, George, 128

I

Inverse Square Law, 36–37
ISO, 32–33, 42

K

Key light, *see* Main light

L

LCD screen, 33
LED lights, 9, 26, 29, 76, 79,
 81, 82, 84, 128, 130, 131
Lenses, 55–56, 95
 flare, 55–56
 telephoto, 95
Light meters, 33, 53–54, 91
Light, modifying, 15, 28,
 68–74, 87, 93, 108–10,
 112–19, 121, 125, 126,
 128, 133, 138
 addition, 28
 beauty dishes, 93, 115–16,
 138
 flags, 16, 68, 72–74, 118,
 128
 gels, 82, 88–89, 118–19,
 136
 gobos, 72–74
 grids, 117–18, 133
 reflectors in environment,
 15, 68–72,
 110–11, 121, 142, 145
 reflector panels, 15, 68–72,
 110–11, 121, 124–25, 142,
 144, 145
 scrims, 45, 72, 73, 108–10,
 115
 snoots, 100, 116, 117, 136
 softboxes, 87, 112–15, 125,
 126, 133, 134, 136, 142,
 145, 147
 subtraction, 28
 sunlight, 20, 52–56, 70,
 120–21
 transmission, 28
 umbrellas, 111–12
Light sources, 9, 26–27, 29,
 38–42, 47–74, 75–119,
 124, 128, 141
 ambient, 38–42, 47–74, 124,
 141–48
 candlelight, 65
 canned, 67, 98, 132
 constant, 9, 26, 29, 76–85,
 130, 131

(Light sources, cont'd)
 fill, 26, 69, 96–97, 128,
 138, 139, 152
 flash, 9, 39–41, 42–44,
 75–119, 122–23, 125,
 126, 132, 133, 134–36,
 138, 139, 145, 147, 152,
 155–56
 fluorescent, 27, 50, 64
 halogen, 76, 81, 84
 LED, 9, 26, 29, 76, 79, 81,
 82, 84, 128, 130, 131
 natural, 20, 27, 46, 47, 48,
 49–56, 70, 71–72, 120–21,
 138, 141
 open shade, 27, 141
 reflected, 59–62, 68–72,
 125; *see also* Reflector
 panels
 tungsten, 27, 76, 141
 video, 9, 26, 29, 76–85,
 128, 130
 window light, 46, 47, 48,
 49–52, 71–72, 138, 141
Lighting patterns, 20–24
Lighting positions, 24–25

M

Main light, 25–26
Midtones, 16
Monolights, 9
Monopods, 83

N

Natural light, 20, 27, 46, 47,
 48, 49–56, 70, 71–72,
 120–21, 138, 141

O

Open shade, 27, 56–58, 71, 141
Overcast skies, *see* Cloudy skies

P

Posing, 50–51, 52
Postproduction, 59

R

Reflected light, 59–62, 68–72,
 125
Reflector panels, 15, 68–72,
 110–11, 121, 124–25, 142,
 144, 145

S

Scrims, 45, 72, 73, 108–10, 115
Shade, *see* Open shade *and*
 Deep Shade
Shadows, 16, 87–88, 95, 145,
 150
Side lighting, 19, 51
Silhouettes, 19, 52
Skin tones, 27
Snoots, 100, 116, 117, 136
Softboxes, 87, 112–15, 125,
 126, 133, 134, 136, 142,
 145, 147
Speedlights, *see* Flash, hot-shoe
Studio strobes, *see* Flash,
 studio strobes
Sunlight, 20, 52–56, 70, 120–21
Sync speed, 39–41, 42–44, 121

T

TTL (through the lens) flash,
 42, 94
Tungsten light, 27, 76, 141
U
Umbrellas, 111–12

V

Video lights, 9, 26, 29, 76–85,
 128, 130

W

White balance, 57–58, 79,
 88–89
Williams, David Anthony, 7
Window light, 46, 47, 48,
 49–52, 71–72, 138, 141,
 150

Z
Zoom controls, flash, 116, 117